GEM

and

STONE

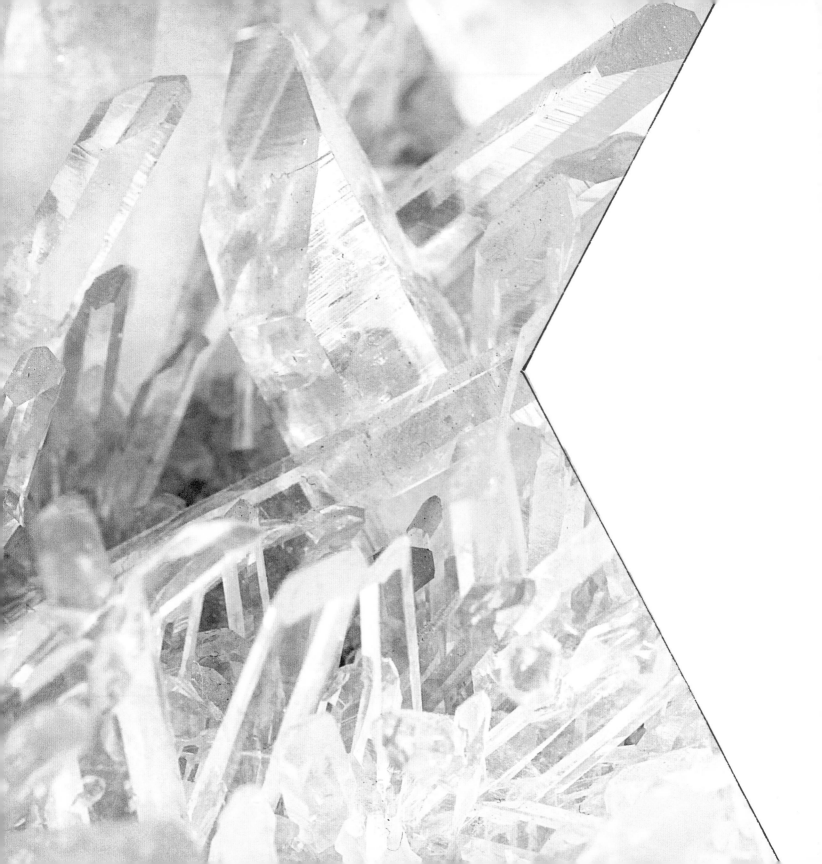

GEM *and* STONE

JEWELS OF EARTH, SEA, AND SKY

by JEN ALTMAN

foreword by THOMAS W. OVERTON
illustrations by HEATHER SMITH JONES

CHRONICLE BOOKS

SAN FRANCISCO

Library of Congress Cataloging-in-Publication Data available.

ISBN 978-1-4521-0907-7

Manufactured in China.

Design by Brooke Johnson

10 9 8 7 6 5 4 3 2 1

Chronicle Books LLC
680 Second Street
San Francisco, CA 94107
www.chroniclebooks.com

To my girls, may you always hold the luster of life
as close to your heart as you do now. I adore you.

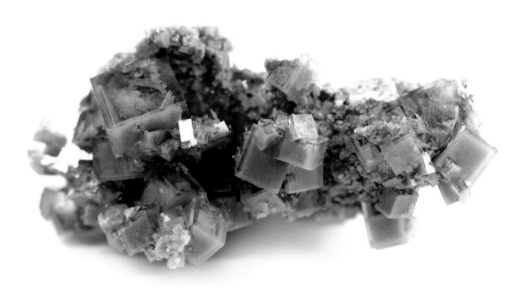

CONTENTS

ACKNOWLEDGMENTS

This book would not have been possible without the generous help of those who allowed me to access their beautiful collections. Special thanks to Connie Olson and Leo McFee at Points of Light in Asheville, North Carolina—your crystal shop is one of the most beautiful places I've had the pleasure of working in. And thank you to Rose Woodfinch, also at Points of Light, for reconnecting me with gem magic. Thank you to Dwaine Ferguson and Heather Kita at Goldsmith Silversmith in Omaha, Nebraska—I am so grateful for the time you took to help me select specimens to photograph, and thank you for making me feel a part of your world. Thank you to Denny Lawing of Riviera Fine Minerals in Charlotte, North Carolina. Your passion for rocks and minerals was contagious, and I am grateful for the opportunity to have spent time with you and your collection.

Additional thanks to Leo McFee for reviewing the metaphysical information in this book for accuracy.

Thank you to Christina Spence for helping me get through the first technical edit on the minerals and for always being my scientific sounding board.

Thank you to Tom Overton for his insightful technical assistance and his generous and beautiful foreword.

Thank you to my dad for buying me my first rock collection after I found that first rock on that hillside when I was eight—it cemented a fascination that has never abated.

Thank you to Heather for her gorgeous illustrations and beautiful charts.

Thank you to Bridget, my editor, who believes in my vision and allows me to execute my ideas in the unbelievably supportive environment that is Chronicle Books.

Thank you to Brooke Johnson for her splendid work designing this book.

And thank you to my incredible family who has been so patient and supportive through the writing and shooting process.

FOREWORD

Human beings have valued gems and minerals for reasons beyond their mere utility for millennia. Indeed, evidence of humanity's obsession with "pretty rocks" predates recorded history. Archeologists believe that the oldest examples of natural materials employed for gem use—some of which may date to as many as 100,000 years ago—were shells, coral, pearls, amber, and the like. Rocks such as turquoise, jade, and lapis lazuli are also of ancient lineage, having been used in the earliest human civilizations.

Though we may struggle to understand the daily lives of the Neolithic peoples who first collected and worked natural materials for their aesthetic and cultural value, and though such people would be reduced to awestruck wonder at modern society, it is likely that one of the few common points of reference—as basic as food, water, and children—would be an appreciation for gem materials. A Neolithic shaman and a modern mineral collector might not be able communicate about much else, but they would share the same reverence for a well-formed quartz crystal.

Gems are mined on almost every continent and in every ecosystem on Earth: from the frozen reaches of Greenland to the torrid deserts of Ethiopia, from the towering heights of the Hindu Kush to the ocean depths off the coast of Namibia, and from the sweltering jungles of Colombia to the arid wastes of the Australian outback. The sole exception is Antarctica, which is protected from mineral exploitation by international treaty—but some geologists suspect it could hold rich deposits of diamonds under its vast ice cap. Gems and minerals know no political boundaries. The world's finest rubies are the product of one of the world's most despotic regimes in Burma, while some of the richest diamond mines on Earth are found in enlightened, democratic Canada. The mining and marketing of gems and collectable minerals likewise touches the full spectrum of humanity: from the poorest subsistence farmers in Africa and Asia, supplementing their income by digging for gems in the dry season, to the wealthiest individuals on Earth. (One of the "gems" in Warren Buffett's portfolio is the famed Borsheims, the largest jewelry store in the United States.) A rough pink diamond dug from a riverbed in Africa and sold to a dealer for a few thousand dollars may later sell at auction to a wealthy collector in Geneva for millions.

The cultural importance of gems and minerals is difficult to overstate. Though preferences vary by region and era, one can track the rise and fall of a civilization through its use of gem materials. The Chinese character for jade, 玉 (*yu*), is one of the oldest in the Chinese language (though it accurately refers to a variety of carving stones, including jade), and the

procession of Chinese dynasties over the centuries is reflected in the artistic styles of their jade carvings. The ancient Greeks and Romans were fond of engraved gems, and the sophistication of their carvings ebbed and flowed with the heights of their empires. India, the only source of diamonds until the mid-eighteenth century, evolved an elaborate caste system for the stones. Colorless diamonds were assigned to the highest caste and were reserved for royalty. Other colors were assigned to priests, merchants, soldiers, and other occupations, with black diamonds left for common laborers (who probably could not have afforded the gems anyway).

Diamonds bedecked Indian royalty for centuries—the maharajahs were renowned for their gem wealth, some of them sporting massive diamond necklaces that would make the flashiest rap artist of the twenty-first century blush. The Mughal emperors of the seventeenth century took things to heights never seen before or since, crafting the legendary Peacock Throne from more than a ton of pure gold and hundreds of rubies, emeralds, diamonds, and pearls. When French gem merchant Jean-Baptiste Tavernier was allowed to inspect the throne in 1665, he estimated its value at 100 million rupees. It's difficult to guess what its value might be today, but on materials alone, it would likely be worth well over $50 million.

Such wealth naturally drew envious gazes. Persian emperor Nader Shah sacked Delhi in 1738, carrying away the Peacock Throne and numerous other priceless treasures. When the British conquered the Punjab a century later, in 1849, one of their first acts was to seize the legendary Koh-i-Noor Diamond and spirit it off to London. There it remains as part of the English Crown Jewels, to the continuing irritation of Indian politicians and historians.

The Indians were, of course, not alone in their use of gemstones to mark high status. European monarchs have used gem-encrusted crowns and regalia as symbols of their might since the Dark Ages, and the Egyptian pharaohs spent vast sums filling their tombs with gold and gemstone artifacts. The gold and emeralds of the Incan rulers, much of it believed to have been stolen during the Spanish conquest, have likewise remained the stuff of legend. Wherever archeologists have looked, from Mesoamerica to Celtic Europe to the vast expanses of Asia and Africa, nobility and gems have gone hand in hand.

Naturally, with gems being prized by so many people of power, they have also spawned numerous wars and conquests. The devastation wrought by the Spanish conquistadores in pursuit of emeralds is a matter of bloody historical record. The British conquest of northern Burma in 1885 was driven in part

by a desire to control the rich Burmese ruby mines—a plan that largely failed, as the Burmese rulers fled with their legendary hoard ahead of the British army. A few years later, diamond magnate Cecil Rhodes (the founder of the De Beers cartel) led his British South Africa Company in the conquest of what would become the nation of Rhodesia (now Zambia and Zimbabwe), largely in pursuit of diamonds and gold.

In the twentieth century, the relationship between gems and conflict has given rise to the term "resource curse." Many of the conflicts in postcolonial Africa can be attributed to a desire to control natural resources, especially diamonds. Bloody civil wars in Angola, Liberia, the Democratic Republic of the Congo, and Sierra Leone in the 1990s—largely funded by trade in illicit diamonds—led to an unprecedented public focus on this issue. The twenty-first century has seen a growing consensus in the gem trade and among consumers that gem mining must support sustainable development and growth, not conflict—though much work on this issue remains to be done.

Humans have also long invested certain gems with magical properties as well as using gems as a means of expressing religious belief and as objects of worship in their own right. Christianity is rich in this tradition—there are gem-encrusted chalices, crosses, monstrances, and gospels residing in cathedrals and monasteries across Europe. Hindu and Buddhist temples in South Asia have long featured gold- and gem-bedecked idols as objects of reverence—some of which are themselves gems. The Emerald Buddha of Thailand, actually a huge jadeite carving housed in a temple in the Grand Palace in Bangkok, is considered so holy that only the king is allowed to even approach it. There are, of course, many other examples—far more than could be listed here.

The belief that certain gems influence one's physical and metaphysical well-being is also ancient and likely reaches back to those Neolithic shamans marveling over quartz crystals they discovered in a rockfall. As they watched how the crystals reflected and refracted light, it would not have been a great leap for ancient holy men to suspect they influenced other energies not as easily seen. Though one can find examples throughout Western history, the richest tradition of "gem healing" is found in South Asia. Even today, most people in Sri Lanka who wear gems do so on the advice of an astrologer.

These are the facts, few of which are open to much dispute. The more difficult question is why. Why do these relatively tiny bits of crystallized materials hold such fascination for so many people?

One might be inclined to answer that gems are pretty. This argument, unsatisfying though it may be

to the scientist, has a certain amount of merit. However much one might protest that beauty is in the eye of the beholder, if majority opinion means anything, it is difficult to review the long history of humanity's gem obsession without conceding that, at least, an awful lot of people find these objects attractive. This isn't the end of the matter, though. Kittens, flowers, and sunsets are all pretty to a great many people, yet none have seen the pervasive influence on human society that gems have.

Gems do have an element of permanence that other beautiful natural objects lack. Most gems are very old; some, like diamonds and zircons, may be billions of years old. Though the Indian maharajahs and the European kings could not have known the full truth of this fact, they surely appreciated that they possessed something far older than themselves.

Gems, and especially fine mineral specimens, represent an element of natural order that is not easy for the human mind to fully grasp, even for those versed in the complexities of chemistry and physics. It is difficult to hold a well-formed crystal of tourmaline or topaz without marveling at the natural forces that brought it into being. In this, a gem or crystal represents an immediate, tangible connection to the vast forces of the universe.

Yet, despite these two qualities—age and natural order—it is indisputable that human beings expend an inordinate amount of energy turning such naturally occurring forms into something else. Fine crystals are cut and polished into faceted gems, lesser specimens are heated, dyed, and even irradiated to improve their color and clarity, massive materials are carved into *objets d'art,* and even ostensibly "natural" mineral specimens are meticulously cleaned and prepared before being deemed worthy of display.

Gems and minerals are also fascinating subjects for scientific study. The science of gems, called gemology, dates at least to the Middle Ages, and is thereby older than a number of important modern disciplines, like molecular biology. Modern mineralogy is itself an outgrowth of early gemology. Though gemology remains a niche field, it supports a billion-dollar industry worldwide, and hundreds of millions of dollars are spent every year to identify, analyze, and grade gemstones for jewelry use. Gems are important to other disciplines as well. The study of gemstone inclusions, especially in diamonds, has provided important support for key areas of scientific study, such as plate tectonics, mantle geology, and the age of the earth.

Yet for materials whose appeal is so tied up with their appearance, it is perhaps ironic that gems and minerals are among the most difficult subjects to photograph. The reasons for this are straightforward. Good photography is a matter of managing light, and

light is what creates the sparkle and color that give gems their beauty. Light that shows a gem to its best effect is not necessarily light that is best suited for a good photo. Another important factor is chemistry: the colors that gems and minerals show to the human eye are usually dictated by their chemical makeup. For example, the green of an emerald and the red of a ruby are both caused by trace amounts of chromium trapped in their crystal structure. Chromium absorbs light in certain wavelengths and transmits it in others. This works well for the human eye, which has evolved to detect fine gradations in color across the spectrum, but doesn't work as well for photographic film, which is composed of chemicals designed to react to specific wavelengths. Until the advent of digital photography, accurately photographing an emerald was next to impossible because color film simply did not react properly to the chromium green wavelengths the gem emitted. The only option was to correct the color after the fact. Other gems will actually change color depending on the lighting. Alexandrite, for example, is famed for its property of appearing green by day and red by night (in candlelight or incandescent lighting)—obviously not an easy subject to photograph accurately.

Gem and mineral specimens are also, in general, quite small. The gem that currently holds the world record for a single stone at auction, a Fancy Intense pink diamond that sold for just over $46 million in 2010, weighs only 24.78 karats, or less than 5 grams—about the size of a grape. Mineral specimens tend to be larger, but even then most are small enough to display on a bookshelf.

For all these reasons, photographing gems and minerals is a pursuit only for the truly passionate. In that, Jenifer Altman clearly qualifies, and it shows in the subtle beauty of these photographs. Like Jen, I came to my interest in gems and minerals as a child, collecting stones that caught my eye, wondering what they were, how they came to be, and what made them look the way they did. While I eventually found myself in the science of gems, she came to embrace the art and folklore. This book is a testament that all can coexist happily, and indeed have long supported one another. Whether you enjoy one or all, there is something here for you.

Thomas W. Overton
former Managing Editor, Gems & Gemology
Gemological Institute of America
Carlsbad, California

INTRODUCTION

When British writer and anthropologist Victoria Finlay received her unique engagement ring, a collection of three thirteenth-century mosaic stones from the Hagia Sophia in Istanbul, she was inspired to begin a journey to seek out not only the sources of the most revered stones in the world, but their stories as well. Her book *Jewels: A Secret History* details her own travels into unfamiliar worlds to discover why we as a people, regardless of time and place, have been captivated by these little objects. Finlay traveled from the seas of the Baltic to the hidden mines in Egypt once belonging to Cleopatra and from the shores of Japan to the heat of Sri Lanka—all in the name of jewels. I have reflected often about her journey and, more importantly, on what she found in each corner of the earth. Her story has caused me to ask what my own attraction to gems and minerals has been over the years. Is it simply their beauty that draws me in, or is there something more?

Two distinct moments in my life solidified my love for rocks and gems. The first was a long and dusty road trip across the Southwest as a child. We pulled over onto the side of the road—my little brother no longer able to contain the Orange Crush he had consumed—and I clearly remember entertaining myself with the stones on the side of a small hill.

There, among the sand and gravel, I found a stone that was the shape of an elongated pyramid with its point lopped off. The stone's coloring awed me—clearly defined bands of earth tones, so perfect it looked as if they must have been painted on. I remember sliding the rock into my pocket, my hand still clenched around it, fearful it would find its way out, and climbing back into the car. I thought of that rock for some time as a good luck charm. Whether it manifested this assignment, I cannot say. However, I do know that it was that particular rock that first sparked my interest in rocks and stones. A rock tumbler, books, and boxed collections quickly followed, and my love of minerals was set. A few years later, pining for the affections of a hockey player in high school, I entered a mineral shop and began to understand yet another facet of the attraction of gems. Looking at a tray of rings—a kaleidoscope of colors—I was immediately drawn to a purple stone cut into a triangle and set in silver. As I picked it up, the sales clerk whispered almost reverently, "Sugilite . . . that, my dear, will bring you love." Does a sixteen-year-old need to hear anything more? And though the hockey player eluded me, I like to think that the stone indeed brought great love and friendship into my life.

The idea for this book began as a fine art photography project. Having recently photographed a

selection of specimens from the zoology collection at the University of Colorado Museum of Natural History, I was eager to begin a new project in a similar vein. Throughout history, people have honored minerals and gems for what they believed to be a power unseen. An object that can manifest itself through the practice of wearing or simply carrying it is a powerful idea and one that is nearly as ancient as humanity. Regardless of cultural or religious boundaries, minerals are one of the elements that unite our interests—nearly every culture in the world and nearly every religion in the world have attributed to gemstones an importance that has transcended time. Holding a piece of jet or amber in the palm of your hand can be a spiritual experience—how often do we have the opportunity to physically connect to something so ancient and so revered? As I began to photograph specimens from my own collection, I loved the idea of creating images that would result in a more intimate experience for the viewer. I wanted to get closer; I wanted to swim deeper; I wanted the visual experience to match the emotion of holding something created by the ever-evolving Earth. The resulting images appear almost as abstract art—yet the canvas is a creation of our world and in some cases, like moldavite, is caused by collisions with something not of this world at all.

The specimens in this book are but a small sampling of the hundreds of species of minerals known. I chose them based on their visual interest, folklore, and mythology as well as their importance in the practice of gem therapy. You may not recognize some of your favorites—the majority of the minerals have been photographed in their raw state rather than having been cut and polished by a gem-cutter. However, I find their raw beauty mesmerizing and hope that you do as well. I took two photos of each stone—one pulled back to show its structure, and one extremely close-up to show the wonders of its surface. The text that accompanies each stone discusses its properties, folklore, and metaphysical attributes. Two charts in the back of the book, illustrated by the amazing Heather Smith Jones, explain the zodialogical and birth-month associations certain stones have traditionally held. My hope is that you find not only beauty in these natural forms, but inspiration; whether you begin your own mineral collection, create your first gem essence, or seek out the museums, shops, and artists featured in the Resources section—somehow you will be moved to bring the beauty of minerals and gems into your life and create your own stories.

AGATE

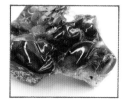

A MICROCRYSTALLINE QUARTZ, agate is a variety of chalcedony that's often marked with banded patterns that are visible once the rock is cut. Some types, such as Moss agate and Sweetwater agate have organic-shaped markings as opposed to bands. The numerous varieties of agate are defined by their patterns and colors and are most often named for the location where they are mined. Some of the more common varieties include Mexican Lace agate (pictured opposite—with Fire agate above) and Brazilian agate.

Agate has been mined throughout the world. With its varying color and banding formations, it's easy to understand why folklore about its properties varies widely. In most cultures, agate was used in ornamentation as both carved jewels and amulets of protection and it was once believed to grant the wearer the power of invisibility. The Romans believed it would aid in bringing in a good crop. In the Middle East, it was thought to keep one's blood healthy. Shakespeare penned roles for agates in several of his works, and agate is listed in the King James version of the Bible in Exodus as one of the jewels placed upon Aaron's Breastplate (see Zodiac and Birthstone Charts, page 120), each stone representing one of the original twelve tribes of Israel. Metaphysical practitioners believe agates to have great healing and balancing powers. Agates remain abundant to this day, and the finest examples are often used to create inexpensive jewelry or are cut to create bookends, plates, and carvings. Originally affiliated with the month of October, agate is the ayurvedic birthstone for May and is also associated with the birth sign Gemini.

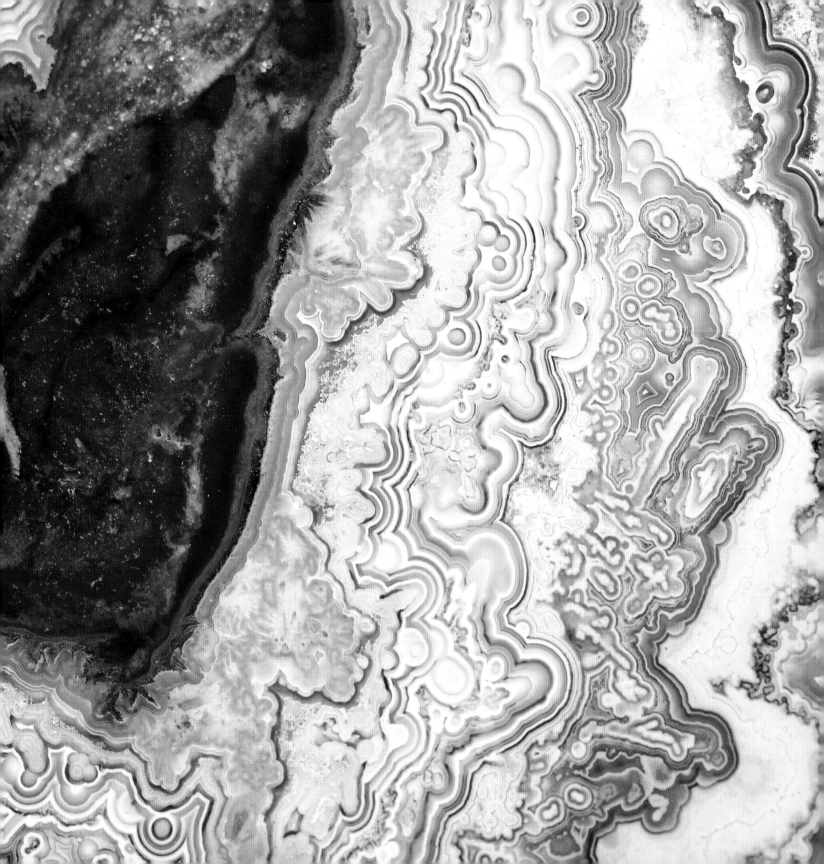

AMAZONITE

AMAZONITE IS THE GREEN-BLUE VARIETY of the common feldspar mineral microcline. While some of the finest deposits are located at Pikes Peak in Colorado, amazonite is also found in India, the Ural Mountains of Russia, and Brazil. Because of its color, it was often confused with jade and was honored in much the same way in early civilizations—handed down with reverence from generation to generation for its believed healing abilities. Also called Amazon stone, amazonite has been used as a powerful talisman of healing and prosperity. It has been set into jewelry and carved into beads since the time of early Mesopotamian cultures. Amazonite jewelry was found in the tomb of Tutankhamen, and it was carved and cut into tablets for the Egyptian funerary text, *The Book of the Dead.*

Modern practitioners of gem healing believe that amazonite is a powerful charm to curb overspending, gambling, and general financial woes. Some healers recommend carrying the stone in a green pouch to avoid such troubles. Along similar lines, it is used to help set personal boundaries and help clarify one's truest and purest intentions, facilitating honesty with oneself and others.

AMBER

AMBER IS AN ORGANIC COMPOUND. When coniferous trees secrete resin to protect themselves from insects or injury and conditions are right, the resin can harden over hundreds of years to create copal. As it continues to fossilize over many millions of years, copal eventually hardens into amber. The oldest specimens are more than 320 million years old, and pieces of amber used as beads and carvings date back to the Stone Age. Gem historians believe that amber may have been one of the very first stones used by humans as a talisman and as jewelry. Amber pieces that contain plant matter are not uncommon, but insects and even animals such as lizards can also be found in it. The latter are exceedingly rare, but highly fascinating, as resin has captured everything from tree frogs to seeds in its warm embrace. While the majority of amber has always been found in the Baltic regions, the stone is also mined from sedimentary deposits in ancient and often buried forests in the Dominican Republic and South America and is still washed ashore by the tempestuous seas of Northern Europe.

Folklore about amber is rich and full of magic. Greek mythology tells of Phaethon, son of the sun god Helios, who rode his father's chariot too close to Earth, setting the world ablaze. To save humanity and the land itself, Zeus struck the boy with a bolt of lightning, and he fell to his death into the River Eridanus. Mourning their brother's death, his sisters vowed to stay with his body for all time. Eventually the girls' bodies turned into trees, and their tears warmed by the sun created amber. Though many stories of the origins of amber are tragedies of Shakespearean proportions, the folklore surrounding amber's powers are full of hope.

Amber continues to be used in jewelry and carvings today. Most examples are yellow, orange, or red. A heat-treated green variety also exists, and rare blue specimens (the color is caused by fluorescence) are highly prized. Naturally occurring examples containing leaves, insects, and other fossils are highly collectable and are most often found in private and museum collections.

Throughout history, amber has been considered a vessel of eternal youth, a symbol of eternal bonds, and an amulet against evil spirits, and it has been worn to enhance fertility and healing. It is believed to symbolize the zodiac sign Leo.

AMETHYST

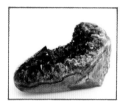

A MACROCRYSTALLINE QUARTZ, amethyst is essentially purple quartz whose color comes from trace amounts of iron. It is found in variations of color ranging from pale violet to deep, dark purple and reddish purple. Amethyst is relatively common and is often found in large individual crystals or smaller crystal clusters. Primarily mined in Brazil, Uruguay, and North America, amethyst is noted for its vitreous (glass-like) luster.

The word *amethyst* is of Greek origin and means "not drunk." It was believed to keep a person sober and quick-witted no matter how much alcohol had been consumed. The Greek myth that tells of the stone's origin underlies this idea: jealous and feeling underappreciated, Bacchus, the god of wine, took his frustrations out on a young maiden named Amethyst. When he released his tigers to kill her, the goddess Diana took pity on her and transformed the girl into clear quartz to protect her from being eaten alive. Some variations affirm that in his guilt, Bacchus poured wine over the quartz to honor the girl. Others say it was his tears that fell upon Amethyst and gave her the noted hue. The theme of sobriety carried on in Roman ideas about how wearing the stone aided in controlling passions and lust; it was believed that wives should wear the stone to keep from straying into the arms of other men.

Fine amethyst was much rarer in the past than it is today, and it was once considered a gem reserved for royalty. It was the stone set into Cleopatra's signet ring, and the Egyptian *Book of the Dead* attributes the stone as the symbol of wisdom. Amethyst was one of the stones set on Aaron's Breastplate, and it has also been highly prized by the Christian church. It continues to be considered a powerful amulet in metaphysical practices and is thought to have a calming, or sobering, ability. Though it has lost its once high monetary value, amethyst is still used in jewelry because of its abundance, and clusters of the stone are popular home accessories. It is both the modern and ayurvedic birthstone for February and is also associated with the zodiac signs Pisces, Virgo, and Aquarius.

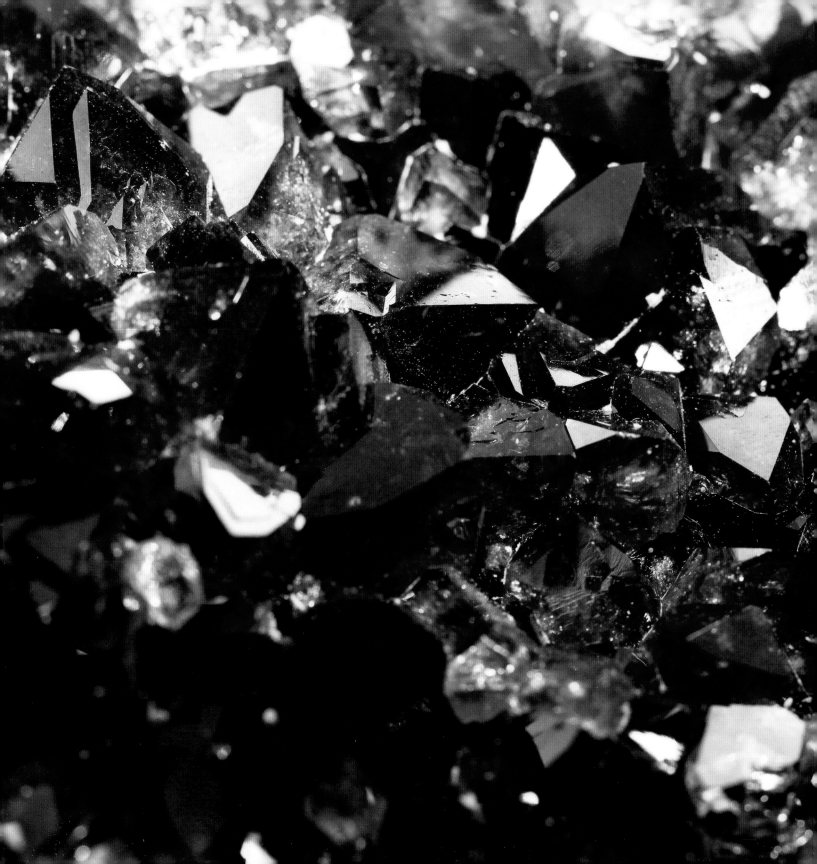

APATITE

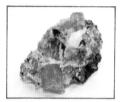

PART OF A SERIES OF PHOSPHATE MINERALS, apatite is a group of minerals that includes chlorapatite (which contains chlorine), fluorapatite (named for the presence of fluorine), and hydroxylapatite (which contains hydroxl). Its forms can be complex, and its colors are intense and vary widely, leading to the etymology of the mineral's name from the Greek word *apate*, meaning "to deceive." In its early mining history, apatite was often mistaken for aquamarine and amethyst. The most significant deposits of apatite are found in North America and Russia.

The nature of gem therapy is somewhat color based, and as a result, there are varying thoughts on the healing properties of apatite. The most notable and most often used types are blue apatite, green apatite, and golden apatite. Blue stones are considered a wind element and are believed to clear cluttered minds and connect one with past or altered life visions. Green apatite (pictured) is a water element and is believed to grant one a vision of one's ultimate purpose, while golden apatite is said to give its bearer reassurance in social situations and to grant courage.

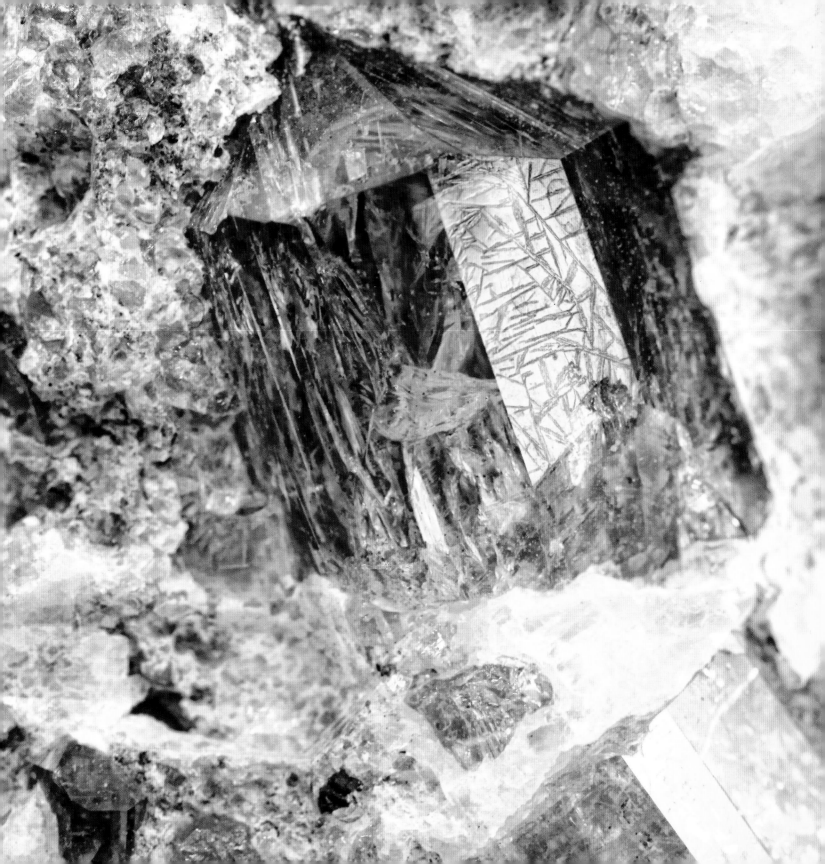

AQUAMARINE

A VARIETY OF THE MINERAL BERYL, aquamarine means "sea water." It is thought to have been named for its pale blue tones. Although it can also exhibit secondary hues of yellow and green, aquamarine is often heat-treated to create a bluer stone for use in the gem trade. It is popular and is most often faceted to accentuate the stone's color. Mined in Brazil, Africa, and North America, the stone often occurs in clean, well-formed crystals prized by mineral collectors. Large specimens of aquamarine are not uncommon, and some huge crystals have been found, including the Dom Pedro, which stood more than twenty-three inches tall before it was sculpted by famed gem-cutter Bernd Munsteiner.

Ancient texts do not refer to aquamarine by name, and we believe that the stone was referred to as "sea green beryl" or "water sapphire." The first use of the modern name was by Anselmus de Boodt in his 1609 manuscript *Gemmarum et Lapidum Historia*. The stone was widely used for medicinal purposes and as an oracle throughout the Middle Ages, and mariners, who believed it to be a gift of the mermaids, wore amulets of aquamarine engraved with the likeness of Poseidon, the sea god, to protect them. It was also common practice for sailors to carry small stones with them to toss into tempestuous seas to appease Poseidon. Even today, aquamarine is thought to protect sailors and fishermen alike.

Aquamarine is the modern birthstone for March and is linked to Scorpio. Its metaphysical properties are thought to be empowerment and facilitating clear communication.

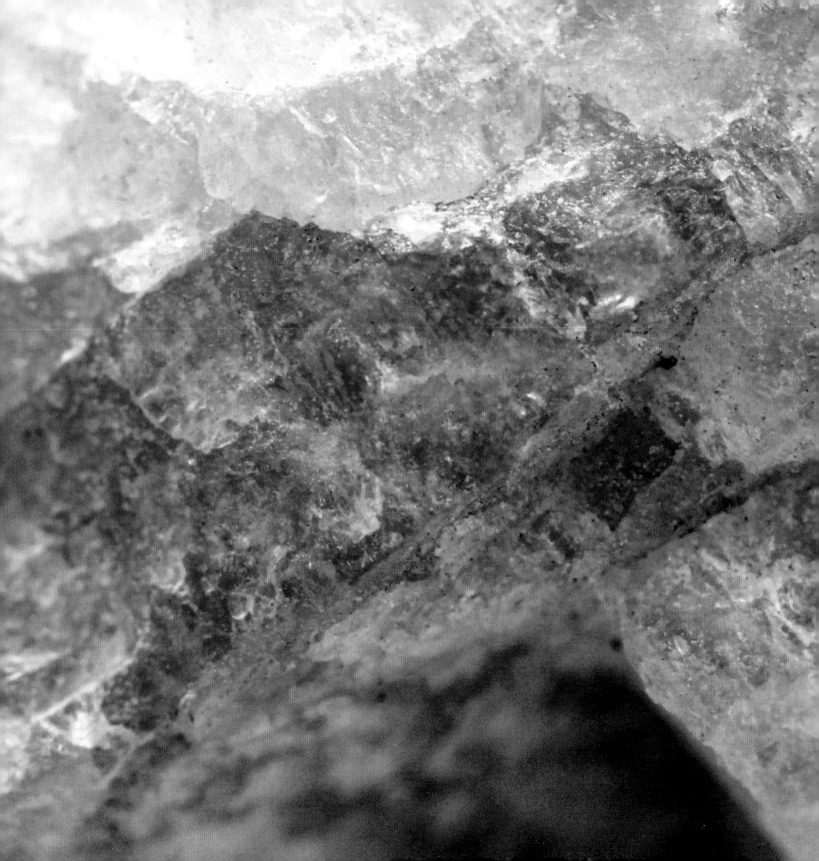

ARAGONITE

ARAGONITE IS A CALCIUM CARBONATE MINERAL and is named for the Aragon region of Spain where it was originally found. It is an important component of many coral, pearl, and shell species. The Czech Republic produces the finest gem-quality crystals, while cave deposits can be found in Mexico, Italy, Greece, and England.

One variety of the stone known by the metaphysical community is Aragonite Star Clusters (pictured here) that form in radiating groups of prismatic pseudohexagonal crystals. Commonly found in Morocco, they are valued among alternative healing practitioners for their powerful energies and are believed to balance the emotional body and to open doorways to past lives. It is thought that the stone will increase the energies of love and emotional strength glowing from those who wear it. Practitioners also believe that Aragonite Star Clusters have the ability to heal broken bones as well as broken hearts.

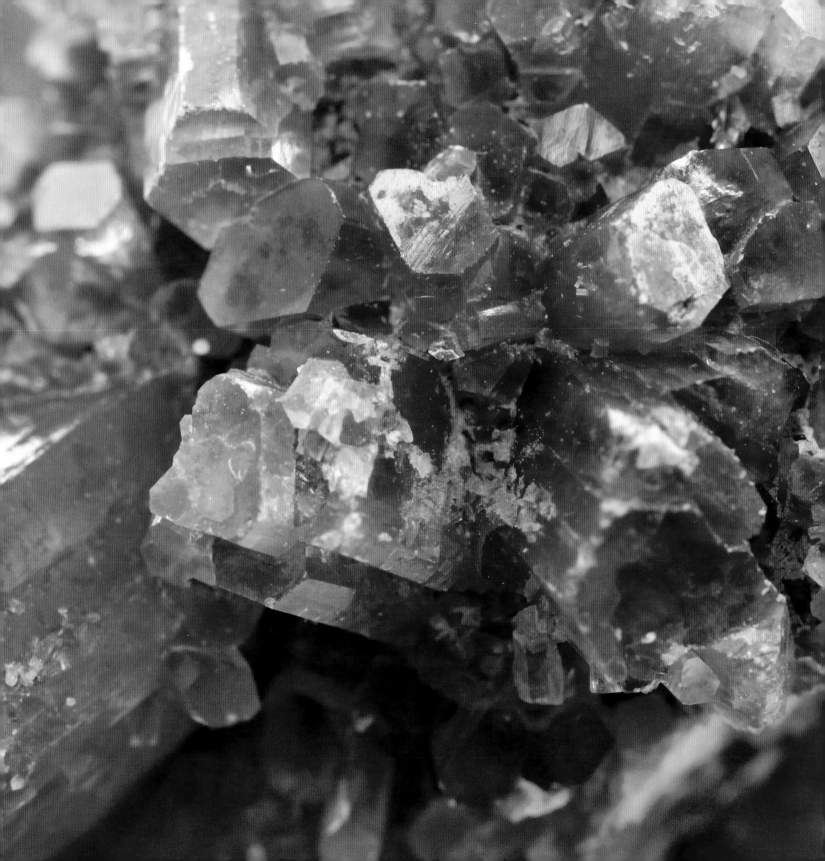

AZURITE

A COPPER CARBONATE HYDROXIDE, azurite is named for its beautiful deep blue color. Formed in copper deposits, it can display more than 150 different types of facial crystal formations (faces), and it is often found intermixed with malachite (where it is referred to as azurmalachite). One of the most interesting varieties of this stone exhibits small bladed crystals and is mined in Chessy-les-Mines, France. Their often vitreous luster can make the specimens look like short crows' feathers, and the finest of these examples were commonly used for ornamental purposes. They continue to be popular additions to personal mineral collections. Very practically, the stone has been used as a pigment in both paintings and manuscripts since the fifteenth century, and it was also mined in ancient Egypt and is believed to form the base of blue glazes used at that time.

Gem therapy practitioners use the stone extensively to facilitate inner vision, and it is believed to be a powerful talisman against psychic harm. It is thought to heighten one's ability to focus on a task and retain information. Practitioners believe that azurite heals all issues pertaining to the head and can be especially helpful in relieving the pain of migraine headaches.

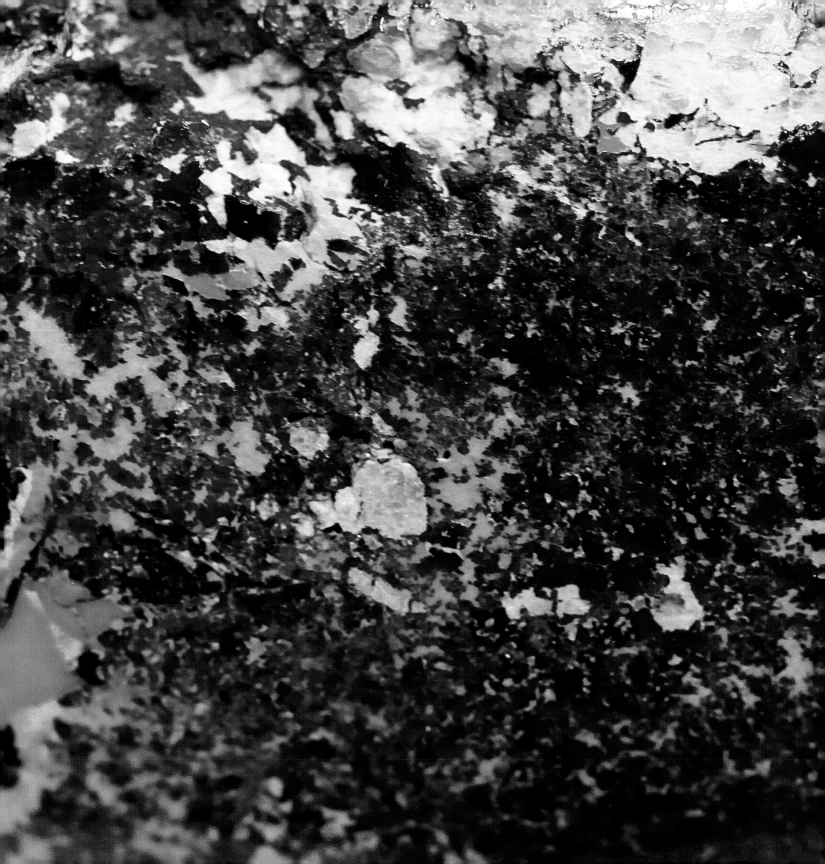

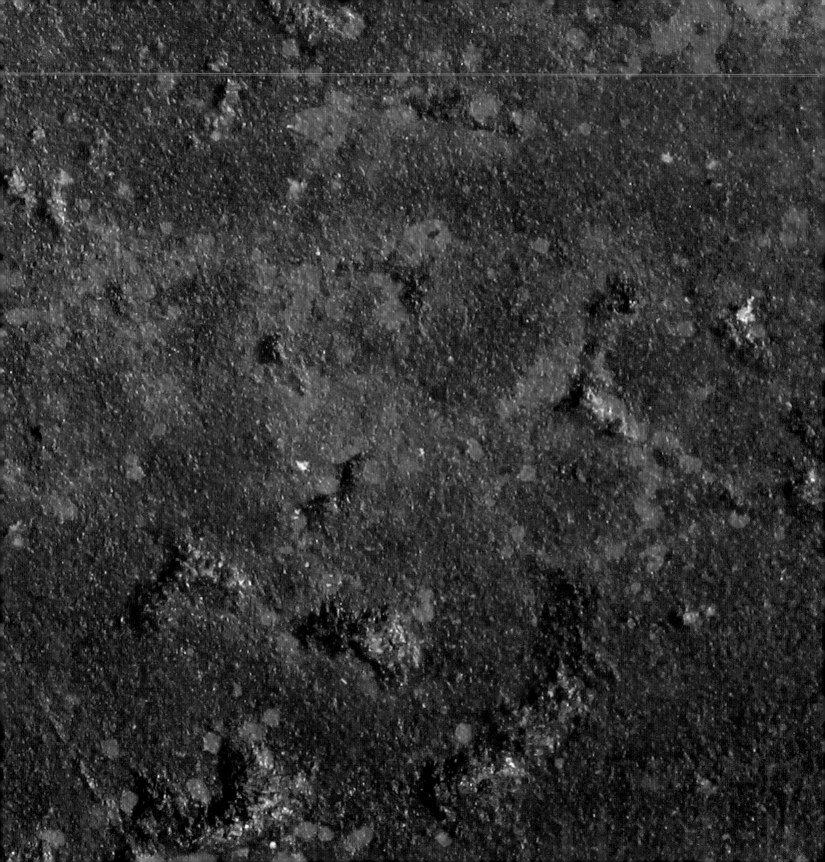

BLOODSTONE

BLOODSTONE IS A VARIETY OF JASPER (chalcedony). Its name is derived from spots of red caused by the presence of iron oxide in the dark green stone. These markings were thought to look like drops of blood. Bloodstone is also known as heliotrope, Greek for "sun turner." The stone was originally mined extensively in India—but the largest deposits are now found in Brazil and Australia.

Several predominant myths surround the creation of bloodstone. In India, a particularly ghoulish story tells of the demon god, Vala. After being killed by the demigods, Vala was dismembered and scattered about the earth and his body parts created all the gemstones that exist. The fire demigod changed Vala's complexion into the seeds that became bloodstone. Another popular creation myth is that when Jesus Christ was being crucified, his blood fell upon green jasper that was under his cross, thus creating bloodstone. As the popularity of this story grew, so did the popularity of the stone, and it became a favorite for carvings of the crucifixion. The most prized of these carvings featured the red markings on the stone where the blood flowed from Christ's wounds.

From ancient Greece through the Middle Ages, bloodstone has been thought of as one of the most powerful of all healing stones. Its connection to blood health was strong. It was believed to stop internal hemorrhaging, blood flow from external wounds, and nosebleeds. Some modern practitioners of alternative healing arts believe it builds marrow and balances major organs. Bloodstone is the ayurvedic birthstone and an alternate birthstone for March and is linked to the zodiac sign Aries.

CALCITE

CALCITE IS A COMMON CARBONATE MINERAL and is a form of calcium carbonate noted for its crystal structures and varying colors. It is found on nearly every continent. Calcite varies widely in formation, translucency, and color, from pale and clear white to deep blue, pink, green, and red. It most commonly forms in masses—rhombohedrons, prisms, and stalactites.

Clear calcite is also known as Iceland spar or optical calcite, and it was once found in quantity in Eskifjord, Iceland. It is doubly refractive, so that looking through the stone from certain angles creates a double image. As a healing stone, it is thought to have many of the same properties as clear crystal quartz and that its ability to refract light speaks directly to attaining multiple levels of awareness. The finest examples of blue calcite are found in South Africa; they are thought to be one of the most soothing stones for emotional healing. Honey calcite (pictured) is found in the same massed or rhombohedral crystal formations, but its color is that of its namesake. It is believed to grant mental clarity.

One noted calcite quarry in ancient times was Hattsub, Egypt. Though the Egyptians called this stone alabaster, it was actually calcite, and it was used for carvings, buildings, and inlaid stones in the eyes of statues. Though not associated with a birth month, it has been linked to the zodiac sign Cancer.

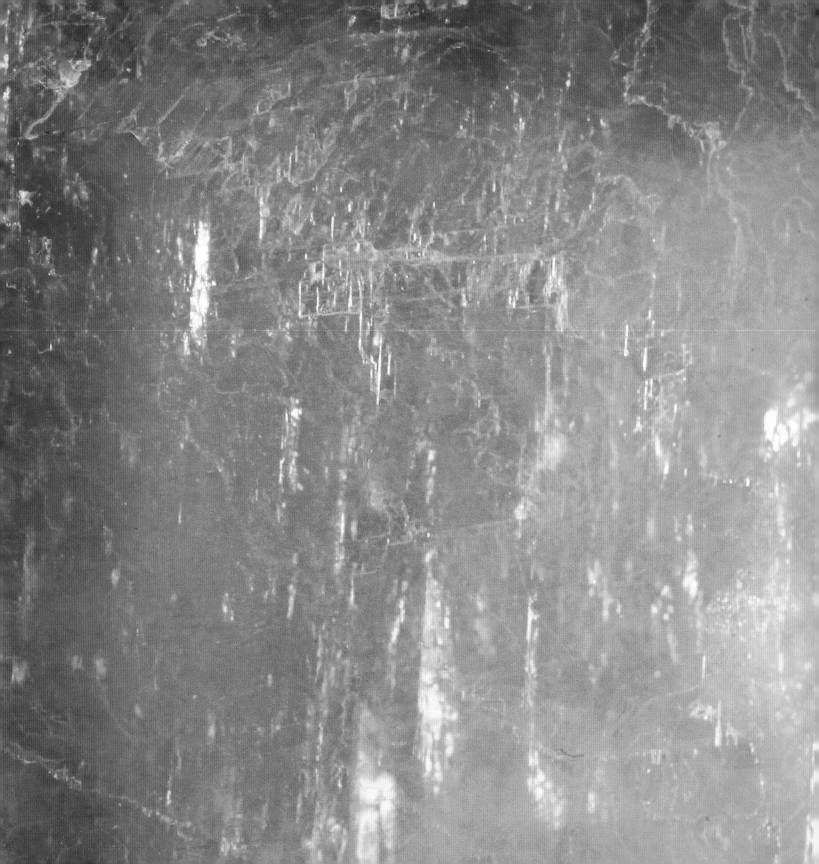

CARNELIAN

CARNELIAN, A VARIETY OF CHALCEDONY, varies from red to pale orange hues depending on the trace presence of iron oxide. When the coloration appears banded, the stone is often referred to as carnelian agate. Miners sometimes placed the stones in the sun to diminish the appearance of brown tones or spots when they were prominent. It was originally mined in India, but now comes from Brazil, Scotland, and the Pacific Northwest of the United States.

Carnelian has been used in jewelry and carvings since ancient Egyptian times. A whole ring could be carved from one piece of the stone, and because it naturally resists sticking to wax, it was popularly used as signet rings by Egyptians, Greeks, and Romans. Egyptians also used the stone in burial practices, placing symbolic carvings within tombs as well as on the body of the deceased to provide protection in the afterlife. It is also believed to be the first stone used in Aaron's Breastplate, described in Exodus, having been brought from Egypt by the Israelites as they fled enslavement.

Carnelian has enjoyed broad appeal because of the various locations in which it was found and because the softness of the stone made it very easy to work with. Muslims and Buddhists alike honored carnelian for its beauty and the idea that it brought one closer to God. Modern metaphysics mirror many of the ancient beliefs that the stone protects the wearer and aids in clear and eloquent speech. It is also the original birthstone for August and is often associated with the zodiac signs Leo and Virgo.

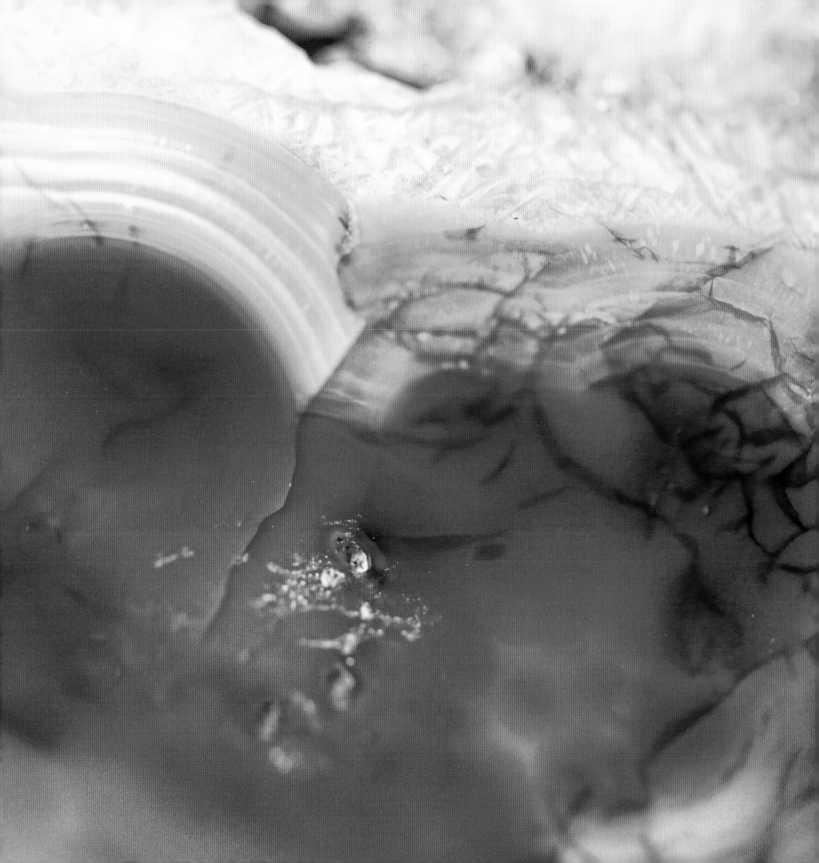

CHALCEDONY

CHALCEDONY IS A MICROCRYSTALLINE QUARTZ that is a milky white when pure. However, chalcedony often includes trace elements of other minerals that yield varying colors and shapes. Varieties include agate (patterned and banded), chrysoprase (green), carnelian (orange), onyx (black and white), bloodstone (dark green and red), and jasper (varying colors and patterns). It is found throughout the world with notable deposits in India, Brazil, and Quartzsite, Arizona.

Used for carvings and amulets since ancient times, chalcedony was once believed to banish fantasies and to diminish nightmares and encourage a restful sleep when placed under one's pillow. Ancient Greeks believed it to be a powerful talisman in battle, and Native Americans used it in traditional ceremonies to encourage stability and harmony. During the Renaissance, the stone became affiliated with the success of lawsuits. In Italy, new mothers wore the stone as a charm to encourage strong lactation. Modern metaphysical beliefs remain aligned with ancient ideas. The mineral is used to calm nerves and restore one's center, balancing anger and anxieties. Chalcedony is also associated with the zodiac sign Capricorn and was the original birthstone for May.

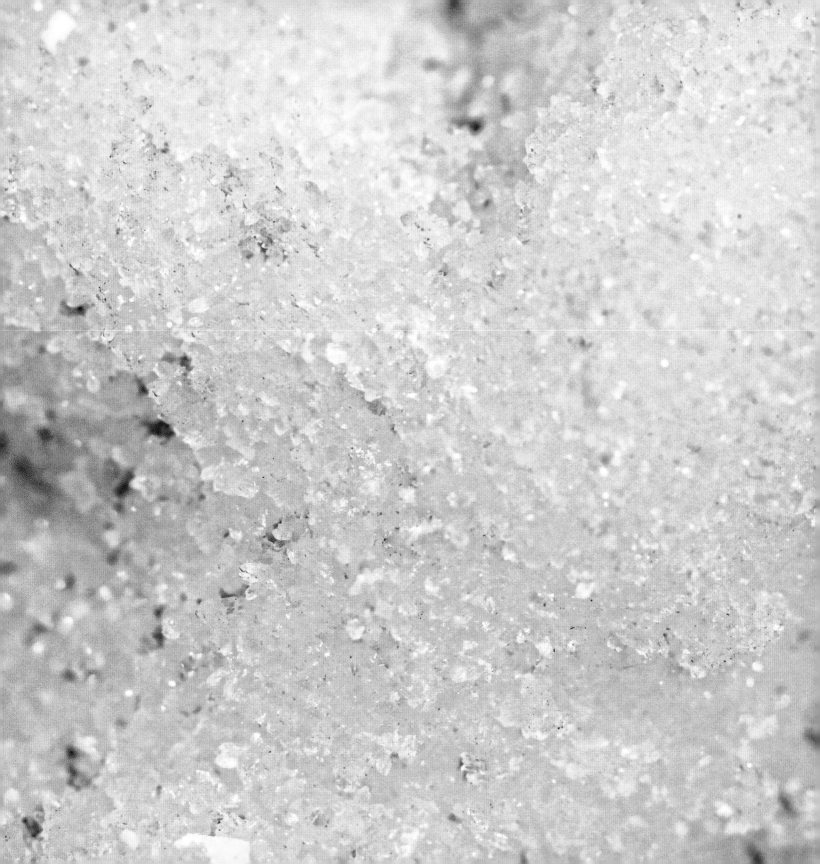

CHRYSOCOLLA

A BLUE TO BLUE-GREEN STONE, chrysocolla is often found with azurite, cuprite, malachite, quartz, and turquoise deposits. It is often found as part of a copper deposit, as it is formed as a decomposition product of the ore's minerals. It is mined throughout the world, including Cornwall, Israel, New Mexico, and Arizona.

Practitioners of gem therapy associate the stone with female energy, and it was once believed to attract love and grant increased wisdom to those who wore it. It is linked to the element of water and is thought to facilitate flow of communication and spiritual cleansing. Practitioners also use chrysocolla to treat throat ailments.

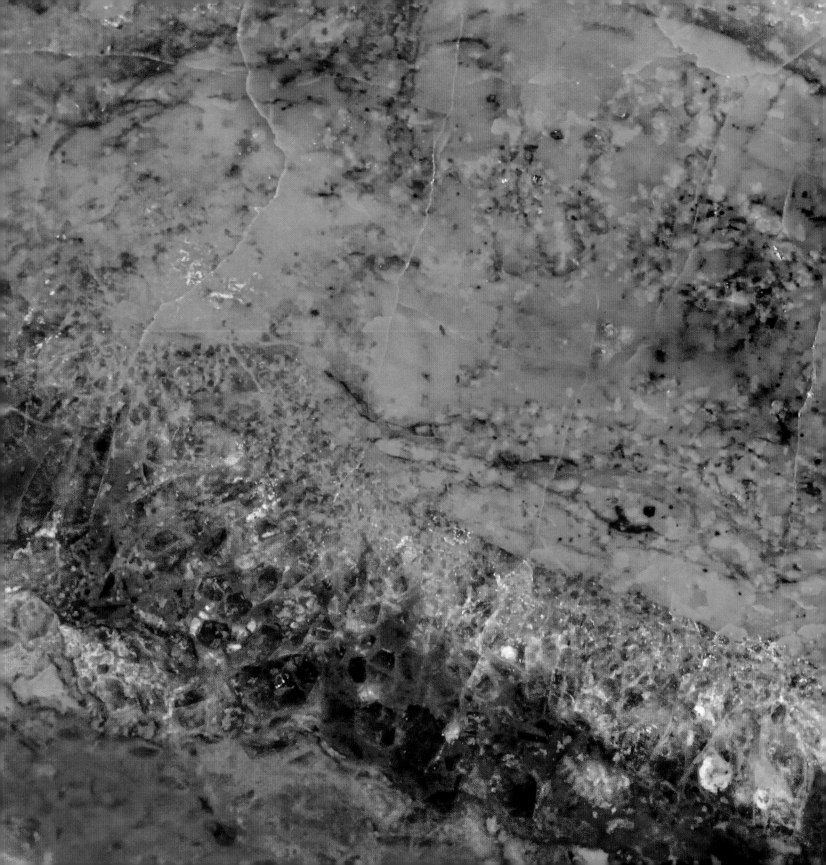

CHRYSOPRASE

A VARIETY OF CHALCEDONY, chrysoprase gets its beautiful apple-green color from traces of nickel, and it is often located among nickel deposits as nodules. This highly valued form of chalcedony has been prized throughout history. Once mined heavily in Poland, it is also found in Australia, California, Brazil, Madagascar, and the Ural Mountains of Russia. Sometimes confused with jadeite, naturally colored chrysoprase is relatively rare; many examples on the market today are actually light-colored chalcedony that has been dyed.

The stone is thought to have been introduced to Europe via the Crusades and was very often misidentified at the time as an emerald. It was both carved into jewelry and crafted into goblets for several European churches, and some of these vessels were even thought to be the Holy Grail. It is also the symbolic stone of St. Thaddeus (more commonly known as St. Jude to modern Biblical historians). One legend surrounding chrysoprase is that Alexander the Great wore the stone into battle as protection—until it was stolen by a snake. In metaphysics, chrysoprase is used as a heart-healing stone, and it is thought to aid in numerous emotional ailments. It is associated with the Zodiac sign Libra.

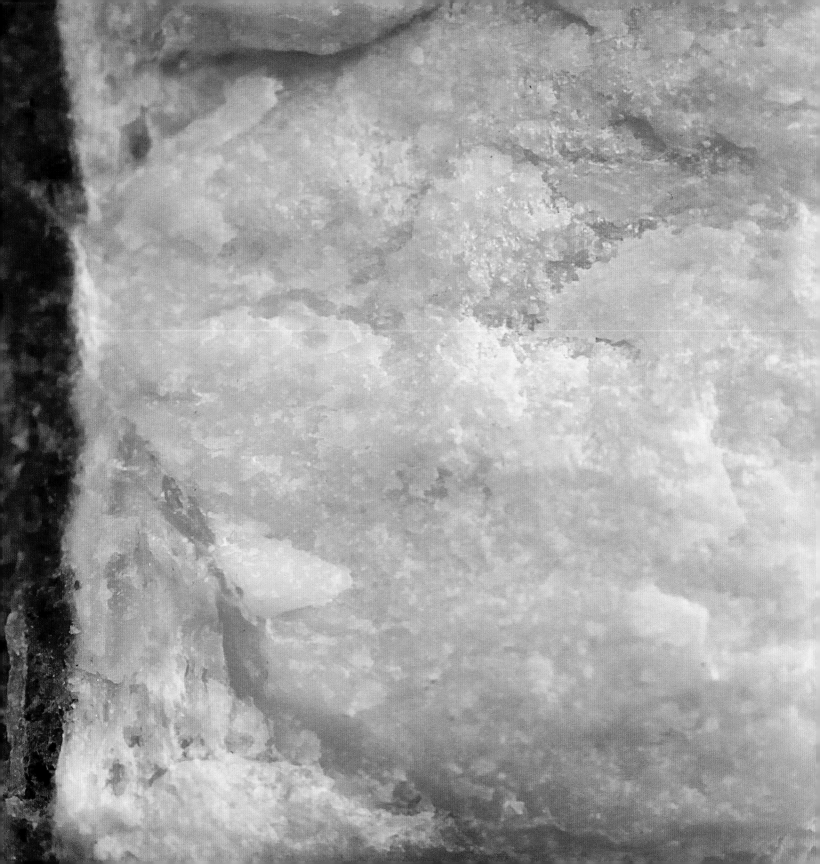

CITRINE

CITRINE IS A VARIETY OF QUARTZ that is colored yellow to medium brown. Its color is derived from the presence of hydrous iron oxide, and examples can vary from translucent to nearly opaque. The word *citrine* comes from "citrus" and refers to its yellow hue. Naturally colored citrine is rare, and most examples used in the gemstone trade are actually heat-treated amethyst. Citrine is mined in many of the same locations as amethyst, but the finest examples are found in Scotland, India, and Russia.

The folklore about citrine is often confusing, because what was referred to in early texts as "citrini" was likely to have been yellow corundum or topaz. The Greeks honored the stone for its ability to fill one's life with joy, and it was believed to bring its owner good luck and prosperity. Citrine is now used widely in the metaphysical realm of healing. Some practitioners believe it to be one of the most powerful stones in realizing one's creative potential and restoring financial health. It is an alternate birthstone for November and has been associated with the sign Gemini.

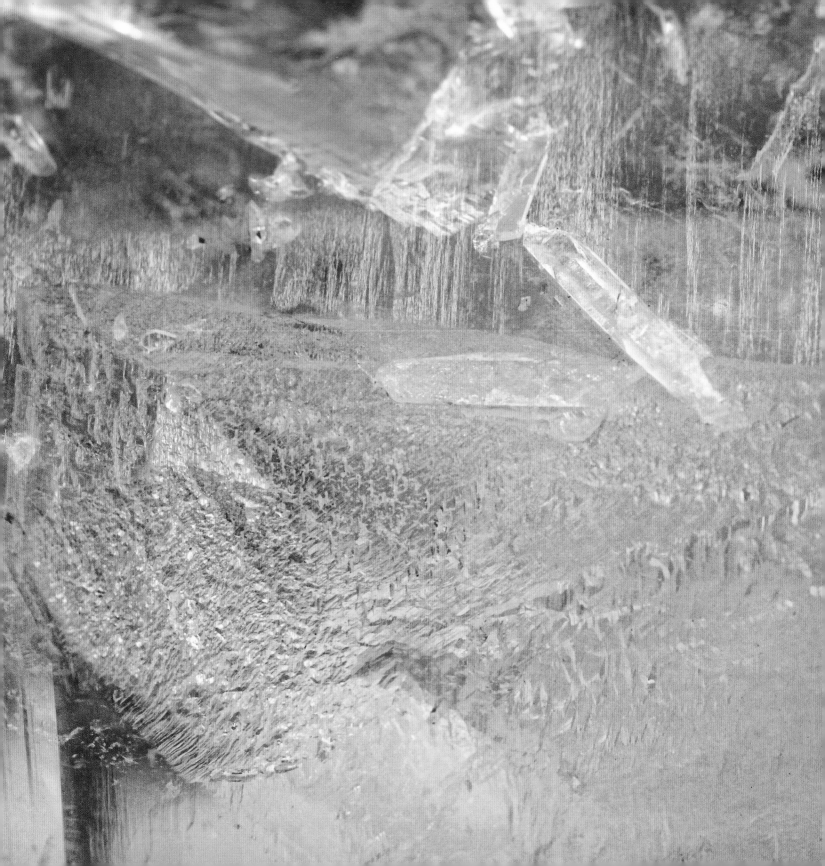

COPPER

COPPER, BELIEVED TO BE one of the first metals to be used by humans, is a native element—meaning that it occurs in nature without the chemical combination of other elements. However, it is common to find copper adhered to minerals such as quartz. It is mined all over the world, but some of the largest deposits are found on the Keweenaw Peninsula in Michigan.

As early as 8,000 BCE, Neolithic people were beginning to use copper. The earliest dynasties of ancient Egypt are thought to have been the first to experiment with casting the metal. It has been used in healing arts since ancient times. Believed to aid in the formation of red blood cells and in repairing tissues, it is used heavily in modern gem therapy as a physical healer. Also believed to link heaven and earth through meditation, and because of its conductivity, copper is considered to be the metal of mythical magicians.

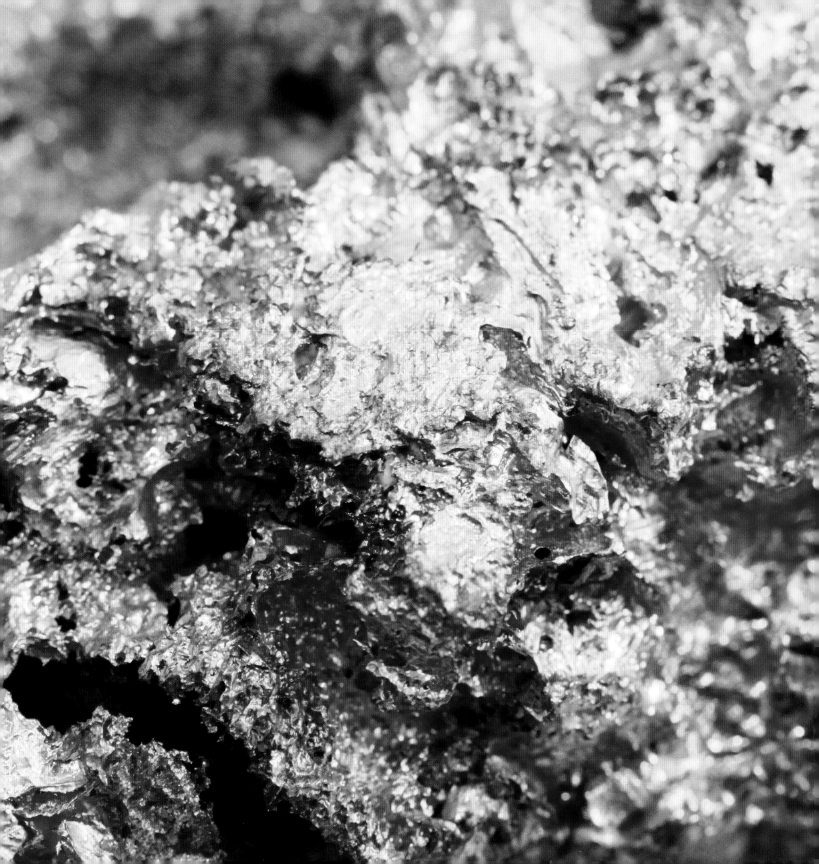

CORAL

AN ORGANIC GEM, coral is created by living organisms. Small sea creatures called coral polyps live in large colonies, and their secretions (for example, of calcium carbonate in the case of the most notable red corals) form coral in branch-like structures that support the colony. Red coral has been harvested for more than 5,000 years. Its color ranges from pale pink and orange to deep red. Black coral is formed from softer organic materials and forms in less spectacular branch formations than red. However, the collection and trading of many species is currently restricted to prevent overharvesting, and most corals remain vulnerable to changing ecological coastal conditions. Fossilized coral, shown in the photograph above, is also called agatized coral. In the right conditions, unharvested branches can eventually turn into agate like this over millions of years.

Coral has been honored by ancient civilizations since the age of the pharaohs. An ancient Greek legend maintained that coral was created when Perseus severed Medusa's head—the droplets of blood creating a gift from the gods. Greeks and Romans alike prized the gem, and it was used as an amulet against poisoning and robbery. It was also believed to imbue its wearer with strength of character and unwavering leadership abilities. Arab cultures believed that to bury a loved one without coral left the deceased's soul highly vulnerable to demons, while Persian culture once maintained that coral was colorless until pulled from the depths of the sea. Cultures throughout history have been devoted to this organic gem, and its association with the sea has been especially honored by people whose existence relies on our great oceans.

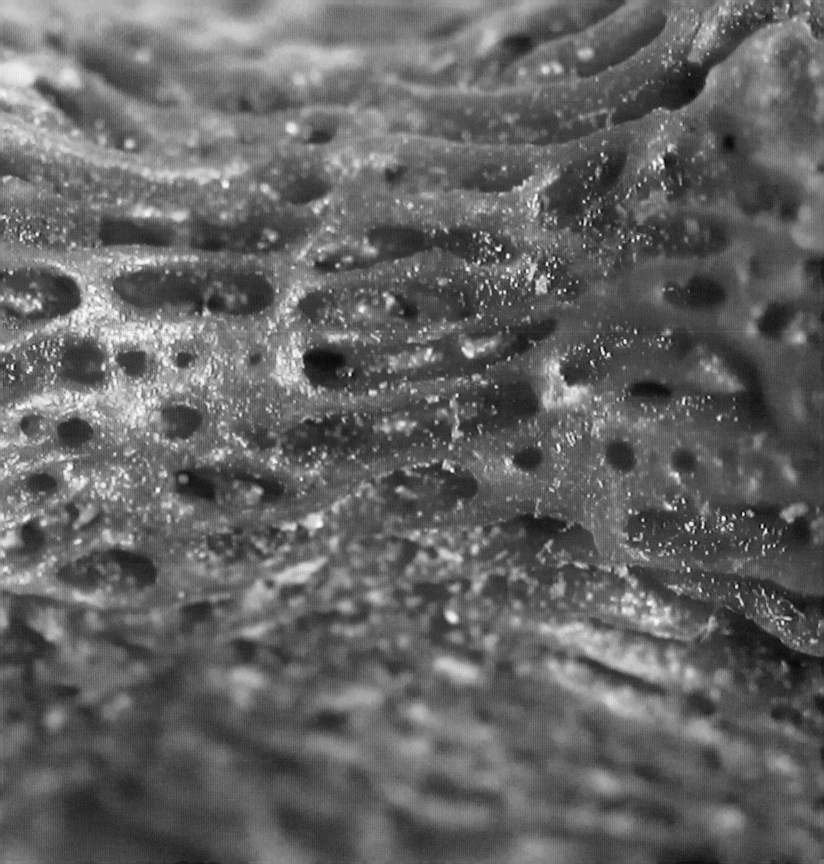

CREEDITE

DISCOVERED IN 1916 at Creede Quadrangle in Mineral County, Colorado, creedite is rare and is usually found among fluorite deposits. Most often found with prismatic and radiating crystals, creedite can be white, clear, pale purple, or orange. It is mined in Colorado, Arizona, and Bolivia, while the finest deposits are located in Mexico.

A popular mineral in metaphysical practices, especially those involving chakras, creedite is used primarily to restore spiritual alignment. It is believed to be an access stone to spiritual interpretations, and practitioners use it to help decipher tarot and otherworldly messages. It has been used in the gem therapy field to overcome addictions and heal the spirit.

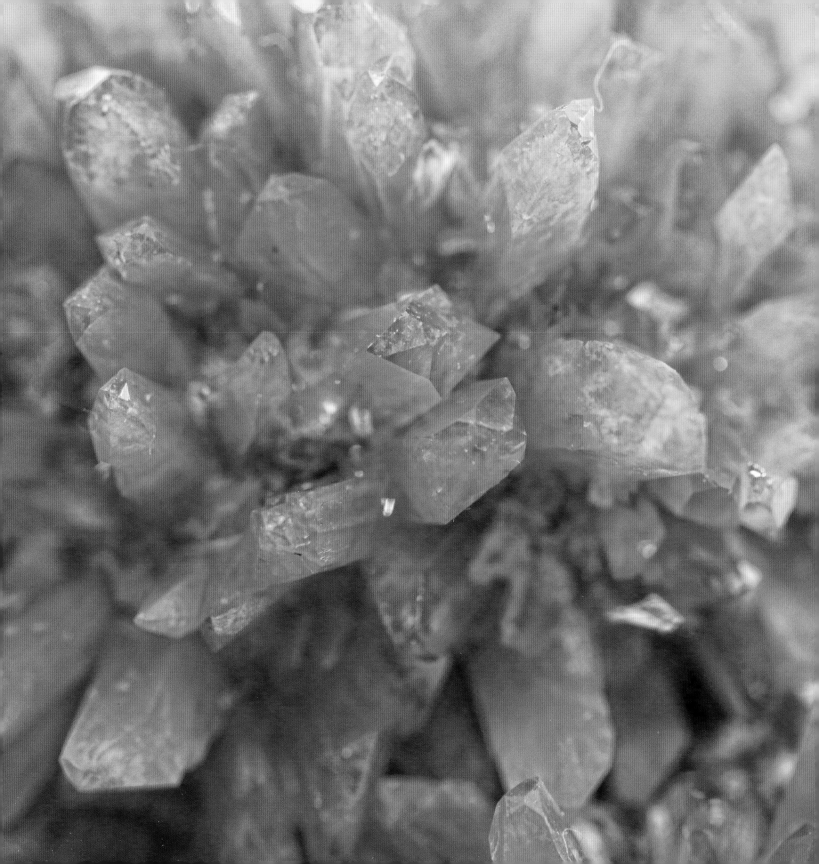

CRYSTAL QUARTZ

CRYSTAL QUARTZ (OR ROCK CRYSTAL) is among the most abundant minerals on Earth. It is identified by its transparency and can form in clusters, long prismatic crystals (as pictured), and druzy (a coating of tiny crystals on host minerals). Notable examples of quartz include milky quartz, which is white and nearly opaque; smoky quartz, which appears in shades of brown to black; phantom quartz, which is typically clear but features "phantoms" of inclusions within the body of the crystal; and rutilated quartz, which features needles of the mineral rutile within the body of the quartz.

Crystal quartz has very rich links to gemstone lore and mythology. Because it is located on nearly every continent, has so many variations, and is so plentiful, crystal quartz has been used for thousands of years by cultures all over the world. Ancient Greeks called the clear stone *krystallos*, meaning "clear ice"—they believed that it was, in fact, ice that could not melt and a gift from the gods. Ceremonial fires lit using the stones' refractive properties were thought to be holy and were used for the highest sacrificial offerings. The idea that clear crystal quartz was once ice and therefore associated with water was prevalent in a number of cultures. Ancient Romans would hold pieces to combat overheating by both summer heat and fever, while aboriginal cultures in both Mexico and Australia used the stone extensively in rain ceremonies. It was also used as a burial stone in a number of cultures, including Celtic and Pueblo Indian. All varieties of quartz have their own folklore and metaphysical attributes. As an example, it was once believed that an angel looked too closely at a forming quartz crystal and her golden hair was forever trapped within the stone, creating rutilated quartz.

Crystal quartz is now mined predominately for the New Age market. Metaphysical beliefs assign different healing properties to each variety and even go as far as to differentiate energies associated with the crystals based on where they were mined. It is believed to be an incredibly diverse healing tool, and crystal balls and pendants continue to be used today to connect one to higher planes of awareness—just as they have been for thousands of years. (For further reading, please see References, page 130.) Crystal quartz is an alternative birthstone for April and is associated with the zodiac sign Aries.

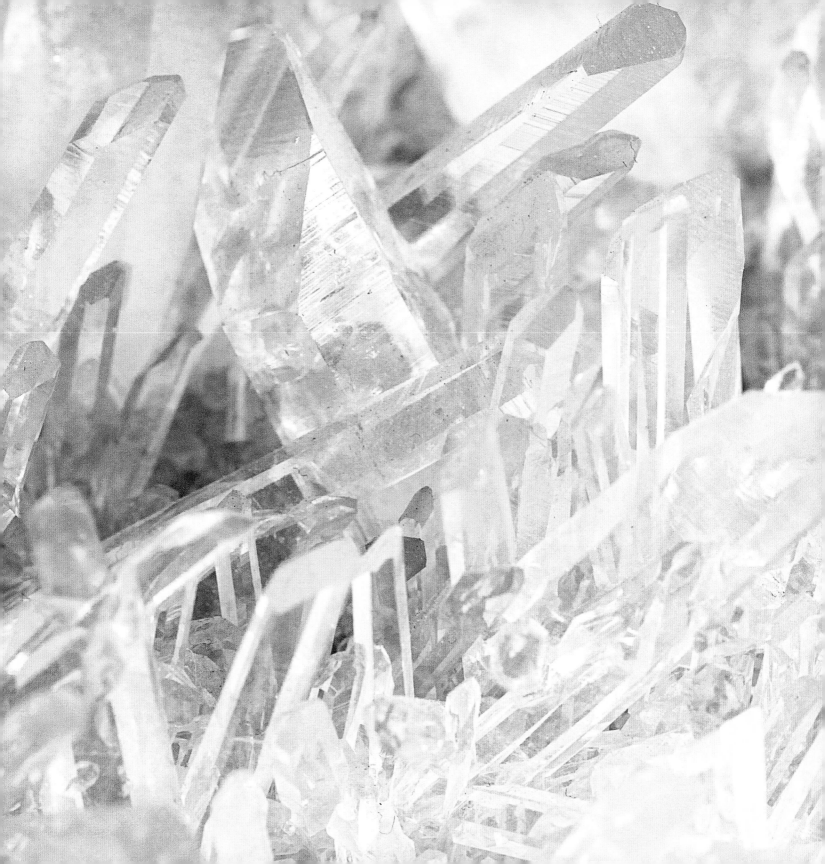

DIAMOND

PURE CARBON, DIAMONDS ARE the hardest mineral on Earth. Diamonds form in the earth's mantle layer and are transported to the surface in volcanic rocks known as kimberlites. The most common colors are brown and yellow, and most are semitransparent. However, diamonds can be black and opaque as well as completely transparent and colorless. Rare "fancy colored" diamonds can occur in almost any color of the spectrum. Attractive "canary" yellows are the most common, while pinks and blues are rare and highly valued. Pure greens, oranges, violets, and reds are exceedingly rare. Some diamonds used in the gem trade are heat-treated to remove color from unattractive browns. Others are irradiated and heated to mimic natural "fancy" colors. Due to the overwhelming and seemingly endless demand for this most precious stone, many mines in Africa have been depleted, leaving the largest working mines in Congo, Angola, Botswana, Canada, and Australia.

While diamonds have been highly revered throughout history, it was not until jewelers in fourth century BCE India made the clear distinction between diamonds and crystal quartz that the diamond began its reign as the "King of Gems." Until the eighteenth century, India was the sole source of diamonds, and some of the most prized specimens in the world, including the legendary Hope Diamond, were found there. Believed to be great sources of magic and protection, diamonds' mythology was linked to their rarity and extreme hardness. Ancient Greeks believed diamonds were the tears of the gods (and how often do gods cry?), while ancient Chinese myths held that the gems grew beneath the sea and could be found only in the bellies of fish. More recently, they have been linked to fidelity and everlasting affection—though this is more of a marketing effort than folklore.

Though the high cost of these gemstones keeps them from being widely used in gem therapy, practitioners believe that they have the power to connect the wearer to divine energies and attest that that is the reason they have been prized by kings and nobles for thousands of years. They are believed to enhance inner vision and induce a spiritual lightness. Diamonds are the modern and ayurvedic birthstone for April and are associated with tenth, thirtieth, sixtieth, and seventy-fifth wedding anniversaries.

DOLOMITE

DOLOMITE IS A WIDESPREAD calcium magnesium carbonate named for the French mineralogist Déodat de Dolomieu. Most specimens display rhombohedral and tabular crystals. The stone can vary in color from white and pale pink to pale green and gray. A minor source of magnesium, it is mined throughout the United States and is also found in Mexico, Germany, Brazil, and Algeria. Rarely set into jewelry, the mineral is abundant and a fairly inexpensive addition to a new specimen collection.

Dolomite plays a strong role in New Age healing. It is believed to be particularly useful to balance anxieties during trying times. Thought to restore inner faith and to keep fear and frustration at bay, dolomite is also used to purge negative energies. Practitioners believe that it creates a sense of self worth and draws upon the user's inner (and often hidden) resources.

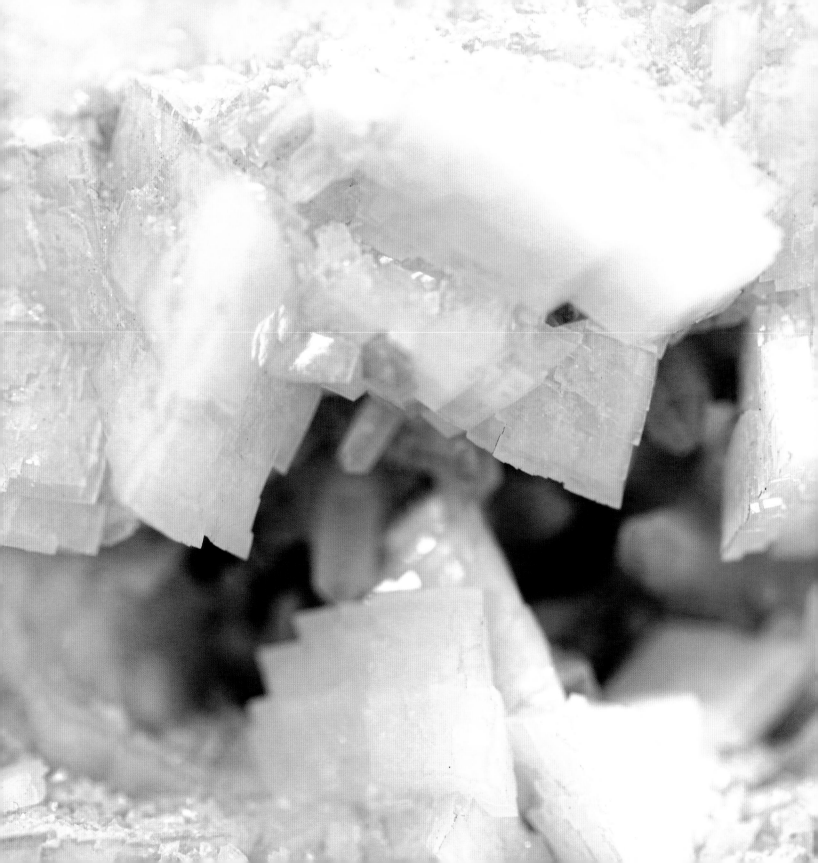

EMERALD

THE GREEN VARIETY OF BERYL, emeralds are one of the most valuable minerals in the gem trade today. Emerald specimens must possess a sufficiently saturated shade of green to be considered emeralds—those that fall outside of this prescribed color scale are considered to be simply green beryl. While the finest quality emeralds can fetch higher market prices than many colorless diamonds, emeralds are almost never flawless—the chromium impurities that create their deep green color, as well as the geology of their growth environment, typically create numerous flaws and inclusions. In the ancient world, Egyptian mines were famed as the source of Cleopatra's emeralds. However, when the Spaniards conquered parts of the Americas, Colombian emeralds soon became renowned as the world's finest. The most important sources of emeralds today are Zambia, Colombia, Brazil, and Russia.

Emeralds have been honored for thousands of years by many cultures. However, specific references are questionable, as research has found that many different kinds of green stones were called emeralds throughout history.

Peridot, verdelite (green tourmaline), and chrysoprase have all been misidentified as emeralds in ancient texts. However, the presence of mines in Upper Egypt—which Alexander the Great would eventually name Cleopatra's Mines—yielded the majority of the authentic emeralds used in ancient times. Ancient Romans used the stones in healing practices. The stones' connection to eyes was made in many cultures, and stones placed in the eyes of a statue were thought to create a spiritual path between the statue and the observer (or supplicant, in many cases). Emeralds have also been a symbol of fertility and, conversely, chastity.

Gem therapists believe that emeralds open the heart to hope and love while purging fear. They associate the stone with the heart and believe that it aids in healing physical heart ailments. Emeralds are the original birthstone for June and the modern birthstone for May. They are linked to the astrological sign of Cancer and are traditionally given on twentieth, thirty-fifth, and fifty-fifth wedding anniversaries.

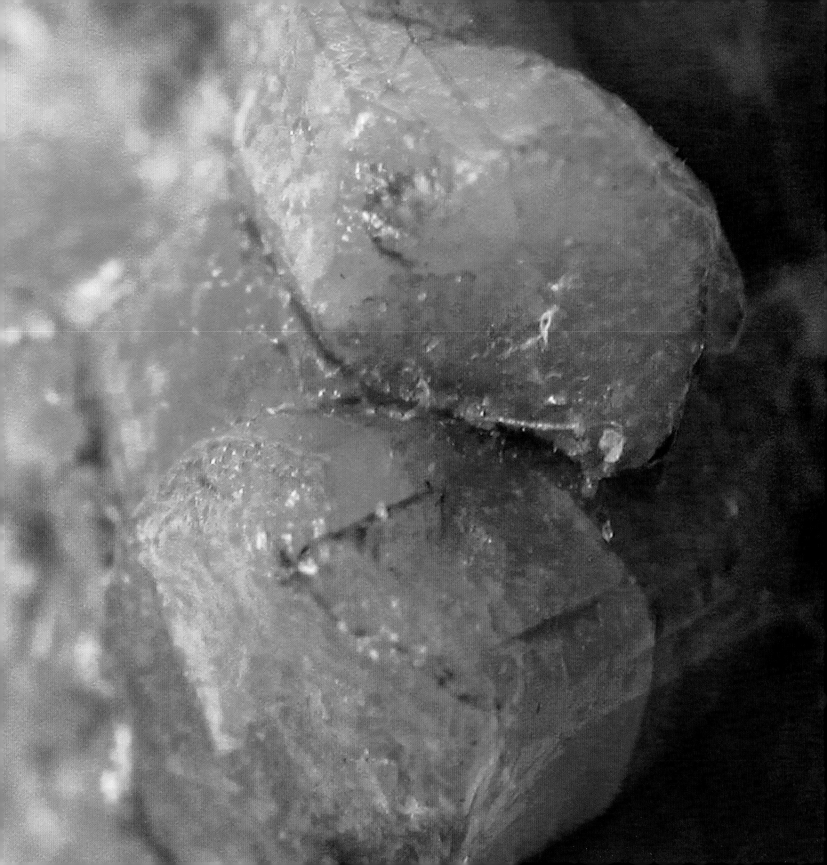

FLUORITE

FLUORITE IS A CALCIUM FLUORIDE and has the most varied color range of all minerals; some specimens can display more than one color. Crystal formations occur as cubes and sometimes as octahedrons and are found worldwide. Some of the finest examples come from Canada, England, and Switzerland.

Fluorite has been used since the ancient Egyptians and Chinese both used the stone heavily in carvings. But a series of mines called the Blue John Mines in Derbyshire, England, would yield some of the most beautiful fluorite on Earth. Banded with purple, green, yellow, and white, the aptly named Blue John fluorite was highly prized during Roman times and was most often crafted into drinking goblets and jewelry. In the 1920s, fluorite was used to create the opalescent glass made famous by Louis Comfort Tiffany and his Art Nouveau creations. Fluorite is also known for its fluorescence—when exposed to ultraviolet light, the stone gives off light. It was the first mineral discovered to do so and the characteristic adds to its beauty and appeal. In fact, the word *fluorescence* is derived from flourite.

Metaphysical beliefs hold that fluorite purges negative energies and thoughts and aids in focusing and can even balance brain chemistry. It is associated with the month of February and is linked to both Pisces and Capricorn.

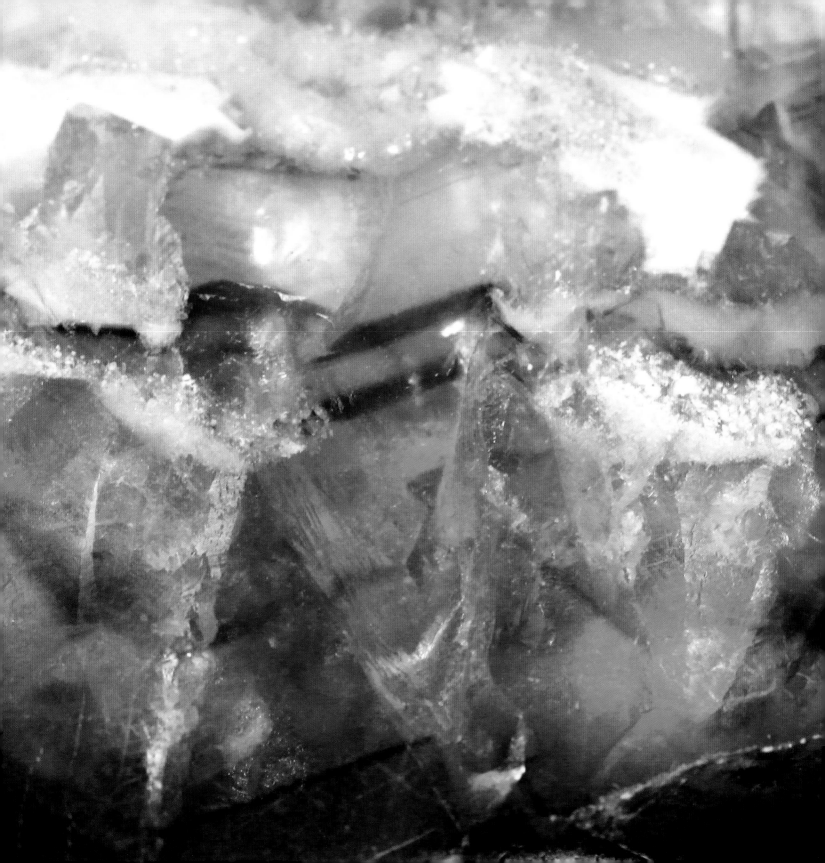

GARNET

GARNET IS A LARGE GROUP OF MINERALS that includes multiple species; many times the varieties blend together in single specimens. Garnets vary in color from deep red to orange and pink as well as green, yellow, and black; some varieties can change color depending on the lighting. All generally form in well-developed crystals that make them easier to identify than many other minerals. Almandine is the most abundant type and pyrope is the type most often associated with the word *garnet*, as it displays the dark and often violet-red used in the gem trade. Demantoid and tsavorite are two green varieties that are highly prized in the gem trade. Garnet is mined all over the world, with the most notable deposits in the United States, India, Sri Lanka, Australia, Russia, Italy, Kenya, Tanzania, Mexico, and Brazil.

The word *garnet* comes from the Latin, *granitus,* meaning "seed-like." Gem historians believe that this name was attributed to garnet because small examples of the gem resemble pomegranate seeds. The Romans attributed the stone to their god of war, Mars, and believed it symbolized fire. Popular throughout the Middle Ages, garnets were thought to be powerful stones that could enliven passion in the wearer, and it was also believed that a garnet featuring the likeness of a lion would guard the bearer from harm. Furthermore, the stone was used to both save and kill. It was used as an antidote against poisons in the Middle Ages and as bullets during the Great Indian Rebellion of 1892. Garnets also play a role in many religious texts. The Talmud states that the stone provided the only light on Noah's Ark; the Koran states that garnet is the light of the Fourth Heaven; and Christian traditions have used the stone to symbolize the blood of Jesus.

Garnet plays a significant role in New Age beliefs as well. Thought to bring about prosperity and pleasure, the stone is also used as a talisman against heart ailments, supports sexual health, and is curative in heart and blood disease. It is both the modern and ayurvedic birthstone for January and is associated with both Scorpio and Aquarius.

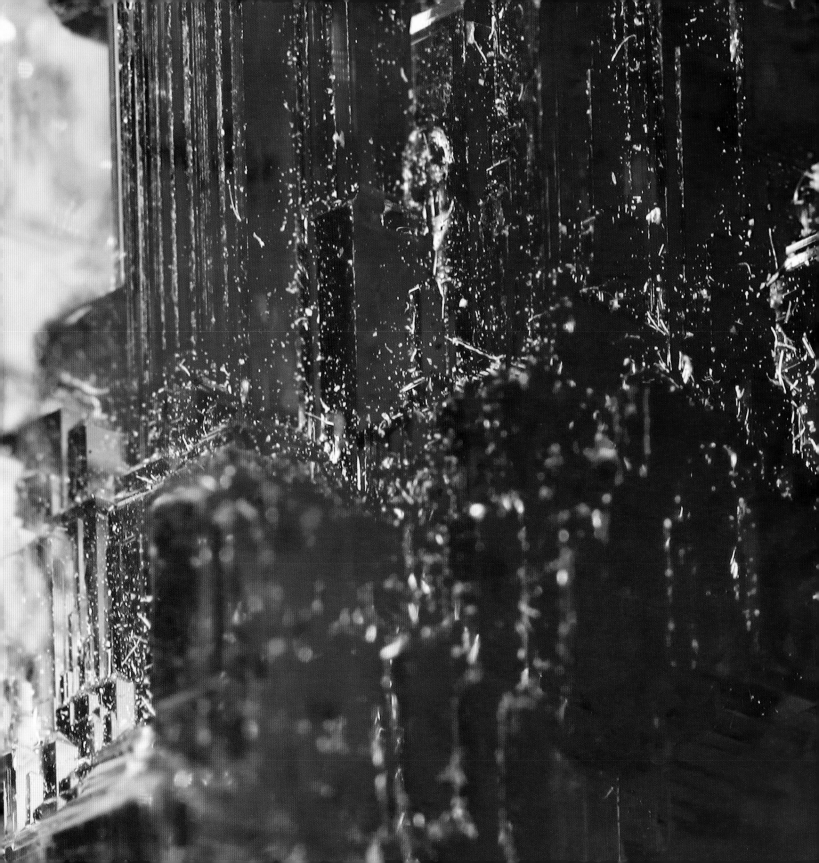

GOLD

USED FOR THOUSANDS OF YEARS for decoration and ornamentation, gold is among the most precious and widely used of natural metals. It forms in several shapes including crystalline masses, flat plats, and nuggets. Gold in its natural state is golden-yellow, but it is usually mixed with other metals to create strength and color variations for use in jewelry design. In ancient times, the main sources for gold were in Egypt and Nubia (modern Sudan). Because of its accessibility, it played an important role in the art history of ancient Egypt. Pharaohs of the Old Kingdom ordered Nubia mined for the beautiful metal, and within a few hundred years Egyptian artisans became extremely skillful, crafting furniture and jewelry with intricate settings for the pharaohs. During the Middle Ages, the largest deposits of gold were located in Saxony and Austria, while large deposits in California and Nevada ignited a feverish desire in the 1840s and in the Yukon and in Alaska in the 1890s and early 1900s, which helped settle the western United States. Current reserves are located in South Africa, Russia, Brazil, and Australia.

While silver and, more recently, platinum have been popular metals used in jewelry, gold is the "gold standard."

That it is incredibly malleable, easily worked, nearly indestructible, and does not corrode add to its appeal. Egyptian and Greco-Roman cultures gilded artwork by adhering paper-thin sheets of gold to surfaces. The ancient Egyptians practiced goldsmithing, and so did the ancient cultures of South America. Gold jewelry that dates to 4,200 BCE has been found in Bulgaria. Some of the finest examples of ancient gold relics are coins, and coins have been used as currency since ancient Greece. Early examples were crude, semiflat pieces, and as craftsmen experimented with the metal, designs became more and more sophisticated.

Because of its rich hue, gold has always been associated with the sun, and its link to wealth is long-standing. The practice of attempting to turn various other metals into gold formed the basis of alchemy. It has been associated with creative passions, fire, and male energy, and since its earliest days it has been harmoniously linked to the divine. Considered a protective metal, it has been worn to ensure long life and continues to be honored today by both kings and common citizens. Gold is the traditional gift for fiftieth wedding anniversaries.

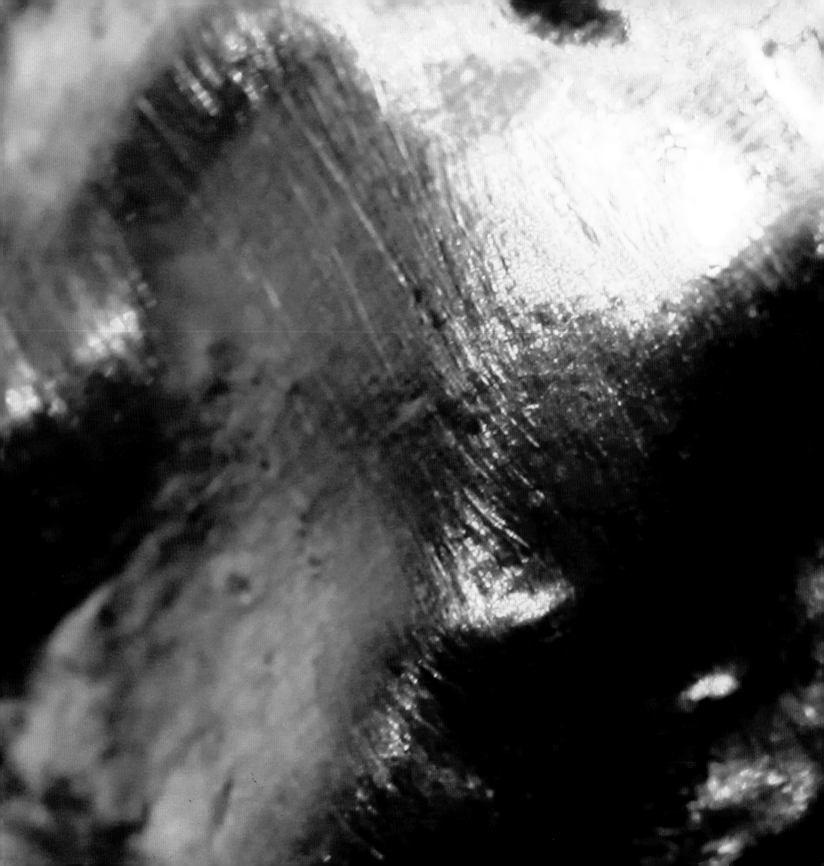

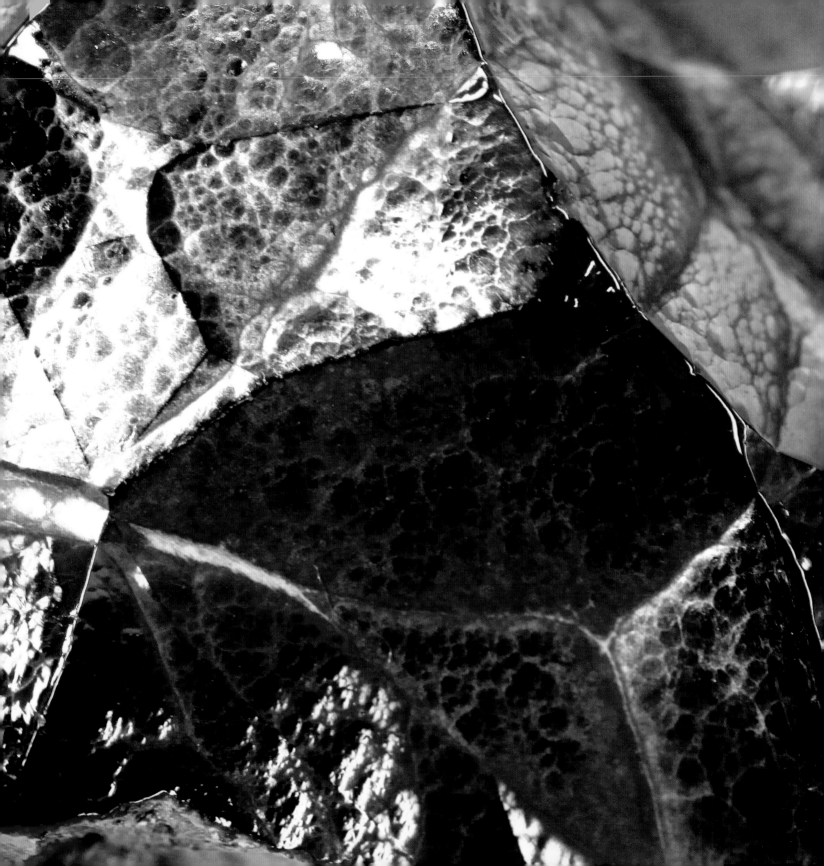

HEMATITE

A PLENTIFUL IRON ORE, hematite is a member of the oxide family. The most notable variety is specular hematite, which is found in great quantities around Lake Superior in Michigan. It forms in dark crystals with a metallic luster. Hematite can also be found as an inclusion in host minerals such as quartz. Some of the finest specimens used in jewelry come from deposits in Brazil and China.

The stone's name comes from the Greek word *haimatitis* meaning "blood-red"—the red in hematite is a result of a high level of iron oxide which is visible if hematite is powdered or rubbed against another stone. Hematite has also been referred to as "the stone that bleeds" because of this streaking characteristic. Its link to blood dates back to Neolithic times when burial grounds were smeared with powdered hematite. Because it was symbolic of the god of war, ancient Greek soldiers would wet the stone and smear red markings on their bodies before battle, and myths from that time period suggest that hematite is the petrified blood of Uranus after he was wounded by Kronos.

Hematite has been highly regarded by many ancient cultures. The Pueblo Indians of North America were particularly skilled at inlaying the stone in artifacts and jewelry. Ancient Egyptian and Roman cultures both used the powdered form of the stone to dress wounds, the iron oxide acting as a natural astringent. Modern metaphysicians use hematite to address mental clarity, and it is believed to be one of the most powerful stones for grounding a person in both spirit and the surrounding physical world. Associated with Aries, Scorpio, and Aquarius, hematite is also linked to the month of March.

HOWLITE

HOWLITE IS A CALCIUM borosilicate hydroxide. Often white with dark veins, howlite's most common use has been as a stand-in for turquoise; when howlite is dyed and polished, it greatly resembles turquoise. However, it is a much softer stone, and experts can easily differentiate the two because dyes used on howlite cannot replicate the beautiful tones of fine examples of turquoise. Howlite is mined in Southern California, Mexico, Canada, and Turkey.

Another name for howlite, White Buffalo Stone—not to be confused with White Buffalo Turquoise, which is in fact turquoise from the Dry Creek Mine in Nevada—has been extensively used in Native American ornamentation. It was named after the White Buffalo, a sacred animal in some Native cultures. In the metaphysical community, howlite is believed to have a very calming effect and to aid in resolving inner conflicts.

JASPER

A VARIETY OF QUARTZ, jasper has been used ornamentally since Paleolithic times. The term *jasper* is often applied to semitranslucent to opaque chalcedonies, however the variety that has been most noted throughout history is the brick-red type that derives its color from hematite. There are deposits all over the world, with some of the finest examples coming from the area around Petrified Forest in Arizona.

Jasper has a long tradition in many cultures throughout the world. In Egypt the stone was revered and thought to symbolize the blood of the mother goddess, Isis. In Egyptian, Native American, and Roman cultures, people used the stone as a protective amulet. It was once believed to stop bleeding, prevent infection, and aid in childbirth. At one time, the Christian church believed that small, pear-shaped examples of the stone symbolized the blood of Jesus. Jasper is the original birthstone for March due to its placement on Aaron's Breastplate, and modern New Age practitioners believe that jasper is a powerful stone to enhance one's physical strength and energy.

KYANITE

AN ALUMINUM SILICATE MINERAL, kyanite most often forms in long, blade-like structures. Its name comes from the Greek word for "dark blue," *kyanos,* and its coloring is most often just that—hues of dark blue tempered by gray. However, green and colorless kyanite have also been found. It is sometimes found formed on quartz and is mined in Brazil, Switzerland, South Africa, Mexico, and North Carolina.

Metaphysical practitioners believe that blue kyanite has high vibrations, allowing for rapid transfers of energies and channels. It is thought to link realms and to awaken one's full consciousness. It is also thought that placing kyanite under your pillow will give you dreams that are clear and wrought with richness. Though it is not associated with any particular month, it is linked to several zodiac signs including Libra and Taurus.

LABRADORITE

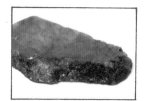

LABRADORITE IS A MEMBER OF the feldspar family of minerals and is named for the location where the first specimen was discovered, Labrador, Canada, in the late 1700s. The way the colors of the mineral seem to change in the light (a phenomenon known as labradorescence) has tinged its mythology and folklore with equal beauty. One story is that labradorite fell from the Northern Lights (or the Aurora Borealis) and that each single specimen holds a blueprint of the universe within itself. If you look at this mineral under light and watch the way the "stars and heavens" move across the surface, you catch a glimpse of this spiritual truth. Another story is that those attracted to labradorite are descendents of the lost city of Atlantis. The interesting juxtaposition of the connections to both the glorious heights of the heavens and the depths of the dark seas make this mineral universally admired.

Labradorite is considered by some as a stone of transformation. Practitioners of healing arts use it to channel positive change and inner strength and to eliminate negative energy. It is thought to calm one's anxieties and to aid in seeing one's true self. While the raw mineral has beautiful physical properties, faceted examples of the mineral are some of the finest examples of the way labordorite plays with and embraces surrounding light.

LAPIS LAZULI

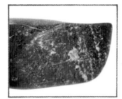

LAPIS LAZULI IS COMPOSED PRIMARILY of the mineral lazurite, which is the source of the deep, gorgeous blues for which the stone is most prized, while traces of calcite and pyrite are often found streaked through the rock. The stone is opaque and is renowned for its color; the blue being so intense some believed it a reflection of the darkening evening heavens. Lapis lazuli is one of the first stones to be used by humans for ornamentation and carvings. The largest deposits were historically found in Afghanistan and Siberia.

Because of its intense color, lapis lazuli forever changed the landscape of art history. Grinding the stone down to a powder and mixing it with binding agents created the pigment ultramarine, which was used extensively by the Old Masters. It is still used in this manner for restoration of fine art. The stone was also highly honored by ancient Egyptians, who believed lapis lazuli to hold great power. It was said to give insight and greater vision and was worn as an amulet and was also powdered to create eye shadow. Once valued more than gold, it is one of the most prevalent stones to be found among the pharaohs' provisions for their afterlife. Sumerians believed it to encompass the energy of the gods, and carrying lapis lazuli gave the bearer the protection and love of the deities. Though it is not as popular as it was during the time of the pharaohs, lapis lazuli continues to be used by jewelers.

Metaphysical practitioners today use the stone to encourage authenticity and harmony in relationships. It is associated with the astrological sign Sagittarius and is an alternate birthstone for September.

LEPIDOLITE

LEPIDOLITE IS PART OF THE MICA GROUP and forms in tabular to short prismatic crystals that range from pale pink and lavender to yellow and gray. It is the most common mineral containing lithium, the lightest of all solid elements. Major deposits exist in Russia, Africa, Brazil, and the United States.

Documented ancient gem lore associated with lepidolite is rare, but its current role in the metaphysical realm is a strong one. Lilac lepidolite from Africa is especially important. Thought to calm nervousness and deep anxieties, it is used by practitioners when patients feel at their most lost and desperate. One practice is to place the stone in a warm bath, letting its energy cleanse the bather. Sleeping with a stone under one's pillow is also thought to curb nightmares.

MALACHITE

ONE OF THE OLDEST STONES mined for its beauty and multitude of uses is malachite. Its name comes from the Greek word for "mallow"—a plant with leafy, dark green foliage. A copper carbonate hydroxide known for its deep green coloring, malachite forms in several shapes. When cut in a cross section, some specimens display gorgeous colored rings and organic shapes varying from pale to dark green.

One of the most famous locations for malachite was the Ural Mountains of Russia. Two large deposits were found in the early nineteenth century, and malachite found its way into the court and heart of the tsar. The Malachite Room in the Winter Palace in St. Petersburg features not only vases and carvings made from the stone, but great pillars and mantelpieces as well. Some of the greatest examples of its use in St. Petersburg are the giant malachite columns inside the famed St. Isaac's Cathedral.

Malachite has been used ornamentally since the Early Dynastic period in ancient Egypt. Carved into protective amulets and powdered for pigment in both paintings and eye cosmetics, malachite was honored among Egyptians and thought to be a part of the gods' physical realm. In the Middle Ages, the stone was used medicinally to treat heart ailments (it was ground and mixed with milk) and was mixed with honey to stop a wound from bleeding. During that time, it continued to be used as a talisman, and new mothers were often advised to give teething children a string of malachite to ease the pain. Its connection to children can be seen in several cultures throughout history, and it was regarded as a stone of great protection for children, thought to keep evil at bay and ensure a restful sleep.

Those in the metaphysical community believe that malachite is one of the greatest of the protector gems. It is believed to guard against mental and physical harm and is thought to facilitate needed change in one's life. Malachite is often associated with the zodiac sign Taurus.

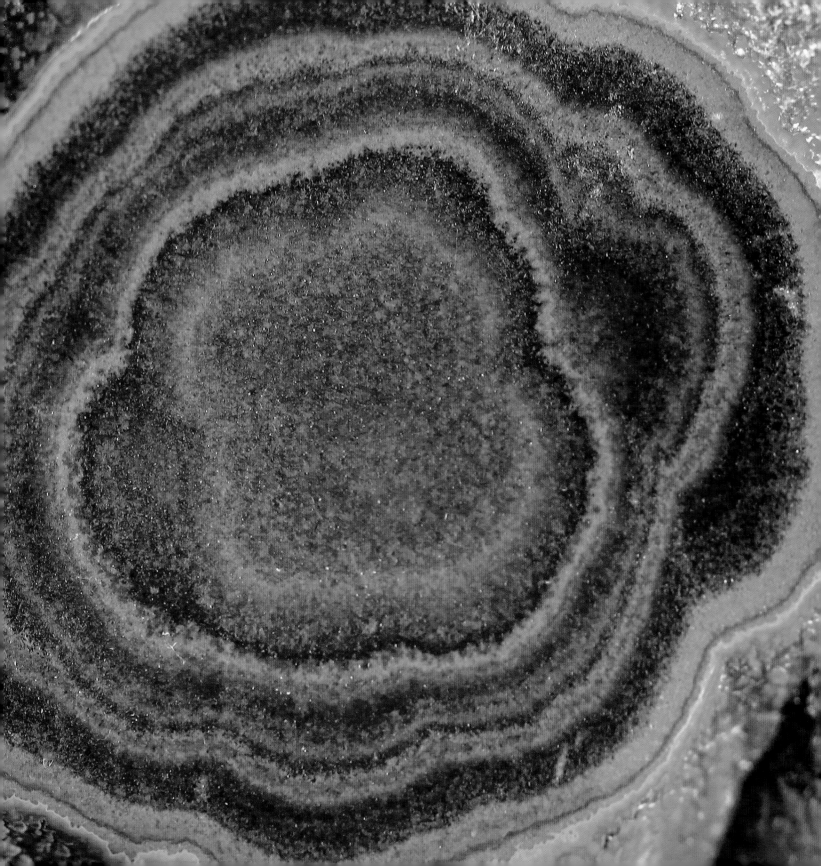

METEORITE

METEORITES ARE OBJECTS that have fallen to Earth. However, very few survive the fall from space and most disintegrate once they reach our upper atmosphere—these become shooting stars. Most meteors are rocks, but a few are composed primarily of iron. Rare meteorites known as pallasites can even contain inclusions of the extraterrestrial gem olivine (peridot). Occasionally, a massive meteorite hits the earth and creates tektites by melting quartz in the earth's crust that later cools to form natural glasses (see moldavite in More Minerals, page 116).

Many cultures throughout the world believed meteorites to be gifts from the gods because of their celestial origins. The Ka'ba, the cubic, black building that is the holiest site in Islam, houses what was once believed to be a large meteorite. It was thought to have been placed there by Mohammed himself, who, having acquired it through Abraham, believed it a gift from God. More recent thought is that the rock is actually impact glass. Meteorites have been used to honor the divine throughout history, including in Greek and Roman temples as well as in early places of worship in Native American, African, and Asian cultures. At the same time, meteorites became prized as a strong material to use to craft weapons. The legendary sword of King Arthur, Excalibur, is thought to have been crafted from this stone from the skies.

In metaphysical practices, meteorite is used to instill patience and curb passions and emotions. It is believed to bring emotional balance and is thought to be especially useful when trying to overcome doubts and frustrations and to glean wisdom from emotional difficulties.

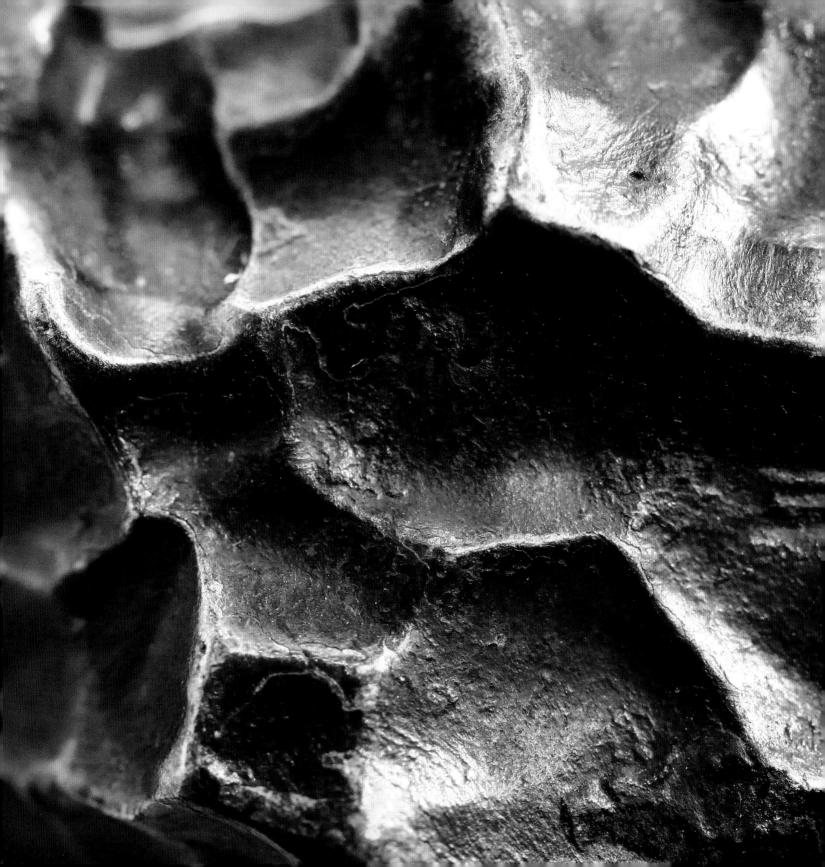

MOONSTONE

MOONSTONE IS THE COMMON NAME for two species of feldspar. Adularia moonstone is within the subgroup of orthoclase feldspar, and most specimens come from Sri Lanka, Burma, India, and Brazil. Albite moonstone (named for the feldspar subgroup albite) is also mined in Sri Lanka and India, as well as in Canada and Kenya. While albite moonstone is much rarer than adularia, both kinds have similar coloring and adularescence (a white to pale blue sheen of reflected light—also called the Schiller effect).

Though moonstone has been set in jewelry for thousands of years, including fine examples from both Asia and ancient Rome, it has been most closely associated with female energies. Symbolizing the moon, a celestial body connected to women throughout mythological history, it was a powerful talisman used by the High Priestesses of goddess-based worship cultures. It is thought to solidify one's relationship with the Great Mother and has been used in efforts to ensure a healthy pregnancy, ease the labor of childbirth, and increase a new mother's milk flow. In India, moonstone remains a most honored and mystical gem. Lovers often exchange the stone as a symbol of their affections, and it was once believed that placing a moonstone in your mouth under a full moon would reveal your true love. Moonstone is the ayurvedic birthstone for September and is considered a secondary or alternative birthstone for June.

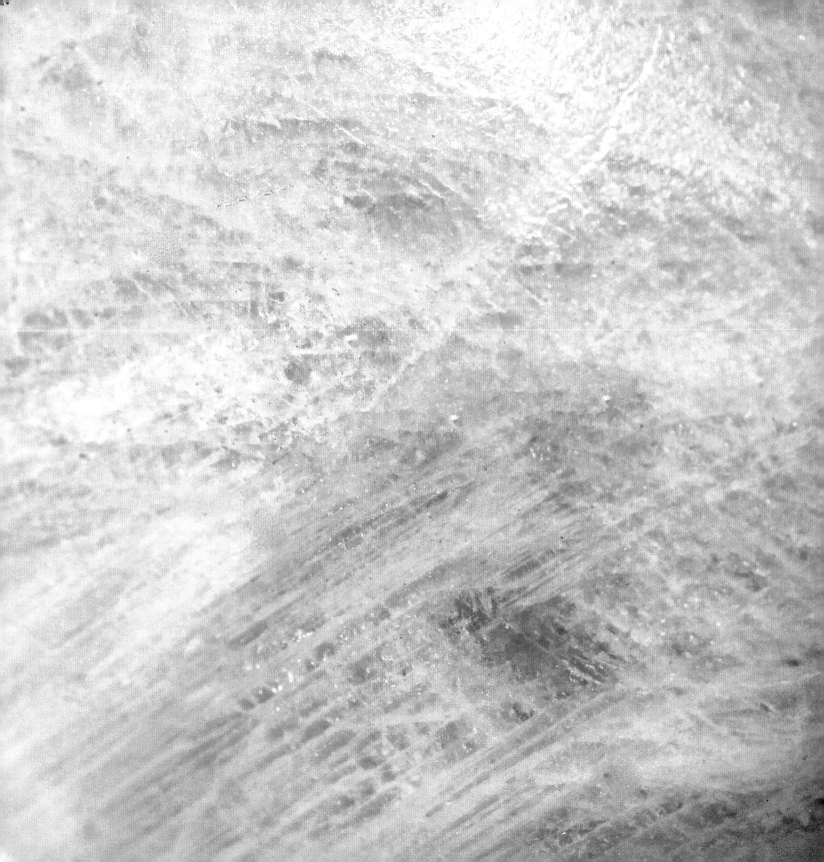

OPAL

ARGUABLY ONE OF THE MOST beautiful gems in the world, opal is known for its play of color—an array of prismatic colors across the body of the stone. A silica gel that hardens over time, opal was once mined extensively in Slovakia; today the finest specimens come from Australia. Common opal, which lacks play of color, is the most abundant but least valued type unless it occurs in attractive colors like blue, red, or pink. Varieties showing play of color typically range from white to gray to black, but brownish and clear (crystal) varieties also occur.

A pale, almost translucent, milky white, white opal (pictured opposite) can contain up to 25 percent water. Romans knew it as the "Cupid Stone." Black opal (shown above) displays the most brilliant colors of all the varieties and is mined almost exclusively in South Australia, where it was discovered in the early twentieth century. Both white and black opals are most often cut *en cabochon* (in a domed, smooth shape) as this cut showcases their color play best. Fire opal, named for its deep red-orange hues, can show play of color and is both cut into cabochons and faceted to highlight its color. Its largest deposits are in the Mexican Highlands, and the stone was once highly revered by both Mayan and Aztec cultures.

Several cultures honor mythology regarding the creation of opal. Tales of Arabian origin insist that opal is what remains on Earth after the ground has been stuck by lightning. Australian aboriginal myths are of the great creator's footprints—every step of the creator left behind the precious gems. The opal is rich with folklore and is one of the few gems that has been associated with both good luck and bad. Its more recent reputation as an ill omen began in the early nineteenth century, and gem historians believe there were several reasons. Because opal breaks easily under pressure, some believe that jewelers themselves began to discourage the wearing of the gemstone to prevent being blamed for damaging it. When royalty who were known to wear the stones regularly began experiencing their own bad luck, its fate was sealed, albeit temporarily. The stone has since been revived within the gem trade and is recognized as the modern and ayurvedic birthstone for October and is associated with the sign Pisces.

PEARL

FEW WORDS EVOKE AS MUCH EMOTION as does *pearl*. The little organic gems have caused joy, heartache, and intrigue. Pearls can form in many species of both freshwater and salt-water mollusks, though not all are valued as gems. When a foreign object—in nature, very often a parasite—makes its way through the shell of a mollusk, the creature goes on the defensive and begins to coat the parasite with a substance called nacre, encasing it. Over time, the casing hardens into what we recognize as a pearl. Pearls can be as small as seeds, irregularly shaped (called baroque pearls, shown above), half rounds (called blisters), and the most coveted, nearly perfectly round form. Today, natural pearls are rare, as the traditional pearl-fishing areas are largely depleted from overharvesting, and collection is often restricted. The vast majority of pearls now on the market are created by culturing. At the turn of the twentieth century, Kokichi Mikimoto perfected the practice of creating round cultured pearls. The Japanese had already been placing small objects within mollusks to create pearls, but perfectly round ones eluded them. Mikimoto found that using a spherical foreign body would force the creation of a round pearl. Today, pearls are cultured in a number of areas around the Pacific—Japan, the Philippines, French Polynesia, and Australia, as well as in freshwater environments in China.

The lore surrounding pearls is full of luster and magic. Julius Caesar was so enamored with them he decreed that only aristocrats could wear them, and he collected them with passion until his death. Romans believed that the pearl was associated with the goddess of love, Venus, and pearls were regularly dissolved for use in love potions. One of the better known stories of drinking a pearl took place during an elaborate dinner party Cleopatra threw on one of her royal barges. Determined to flaunt her wealth in front of her newest conquest, Mark Antony, she plucked the large pearl earring from her ear, dropped it ceremoniously into her goblet, and drank the contents. Many Asian cultures have aligned the creation of pearls with their deities. In Japanese folklore, pearls were thought to be the tears of a mermaid-like sea goddess named Ningyo. They were also believed to have fallen from the sky and into the ocean as gifts from the gods.

Pearls are the modern and ayurvedic birthstone for June. They are thought to have strong healing abilities for those born during that month. Pearls have steadily maintained their popularity throughout history (except for the pearl "crash" of 1930), and though the practice of pearl farming has made them widely available, the demand for them remains high.

PERIDOT

PERIDOT IS THE GREEN-HUED gem-quality variety of the mineral olivine. Olivine can also appear in yellow and golden tones—these gems are called chrysolite. Peridot has been mined for more than 3,500 years. The best deposits are located on St. John's Island, in the Red Sea, in Pakistan, Brazil, Australia, Africa, and Arizona, and on the shores of Hawaii.

Because of their beautiful green hue, peridots were often confused with emeralds in ancient times. However, there is evidence that the stone was popular in its own right as well and was carved into beads by ancient Egyptians and was highly honored. It is believed that the pharaohs placed sentries to guard the peridot mines around the clock, and punishment for smuggling the stone was death. The stone was also a popular choice for signet rings of the time, and the pharaoh Ptolemy II commissioned a lifelike statue of his queen carved of peridot. (However, recent research suggests that the mineral was in fact green fluorite.) During the Middle Ages, the stone was thought to act as a powerful talisman against evil and demons and symbolized the sun. It was also used to counter nightmares and frighten away ghosts. There is some debate about the stone's presence in Aaron's Breastplate, as most references refer to chrysolite (the golden-colored variety of olivine), but of course, no one can be sure. Peridot also holds a place of honor in the Apache tribes of North America, and the tribes remain the sole landowner of one of the largest deposits in the world. Peridot also has the notoriety of being the only gemstone known to form on a planet other than Earth. It can be found in rare meteorites known as pallasites, and deposits were located on Mars in a 2003 expedition.

As a tool of "increase" in gem therapy, peridot is used to build wealth, health, emotional stability, and insight. It is thought to be the original birthstone for September and it is the modern birthstone for August. It is also linked to the sign Libra.

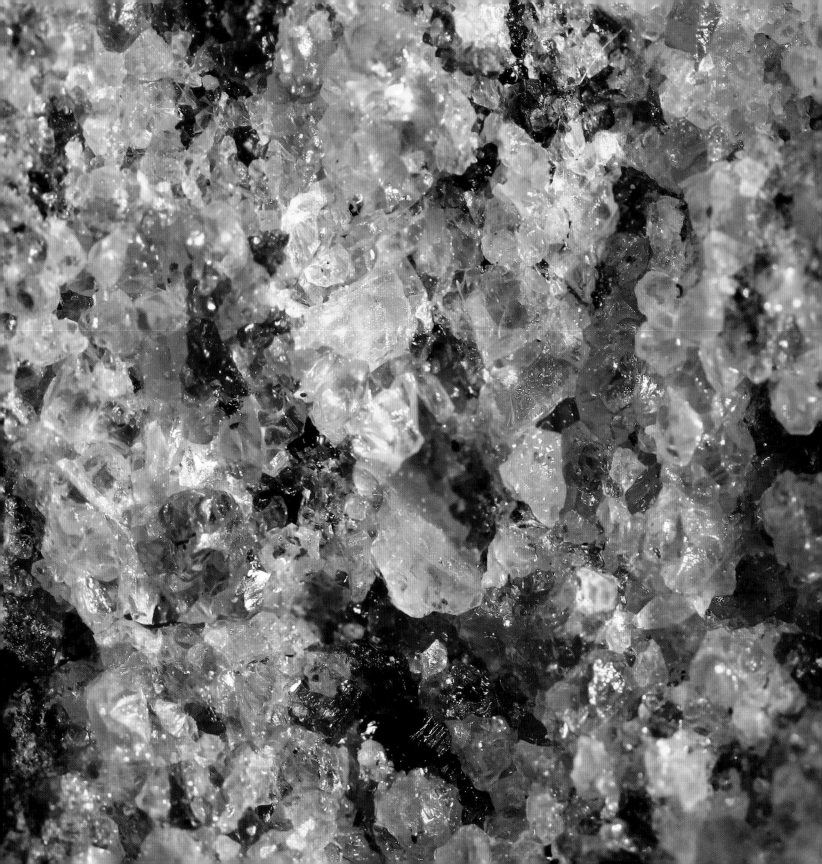

PETRIFIED WOOD

PETRIFIED WOOD IS JUST THAT, wood that has fossilized over millions of years. Sometimes, after a tree died in an ancient forest, it fell into a body of volcanic, ash-rich water and was buried in sediment. The silica in the ash eventually replaced the organic components of the tree and formed chalcedony. One of the most important places to witness this natural phenomenon is Arizona's Petrified Forest National Park. Other notable sources of petrified wood include Egypt and Brazil.

Today, slabs are used as home decor and are crafted into jewelry. In metaphysical practices, the energy of petrified wood is a reflection of its original source. Believed to be a pathway to the Wise Ones, it is said to provide the roots of knowledge and spiritual connections; and to encourage slow and steady growth toward transformation.

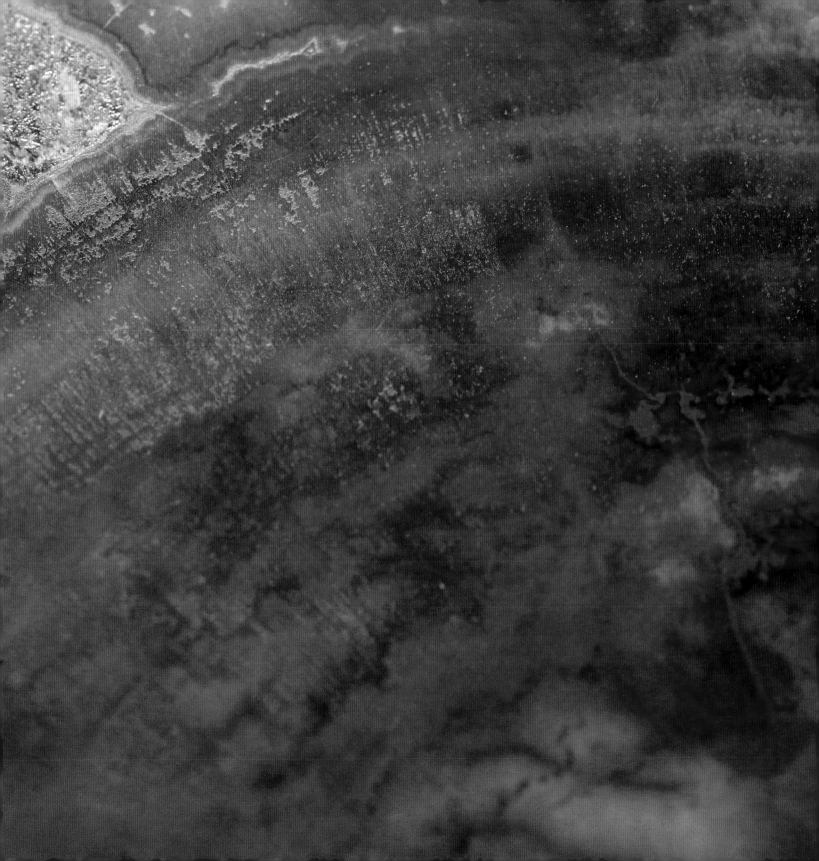

PYRITE

PYRITE, WHOSE NAME COMES FROM THE GREEK word *pyr*, meaning "fire," is a golden- to brass-colored iron sulfide. It has been widely called "fool's gold" due to its gold-like appearance and has been the bane of many novice prospectors throughout history. Pyrite occurs in several distinct formations including nodules, cubes, pyritohedral crystals, and flat disks called pyrite "suns." It is mined worldwide, with noteworthy deposits in North America, especially California and Colorado, Spain, and Brazil. Pyrite has been symbolically associated with fire because it will spark when struck by iron. It was also used in the mechanics of wheel-lock guns.

Mesoamerican civilizations used pyrite for its reflective properties as scrying mirrors (used to see future events), while Native Americans used amulets of pyrite for protection. These pyrite amulets have also been found among the precious objects in the pouches of medicine men, attesting to their importance and believed powers. There are also references to the mineral being used in early China to prevent crocodile attacks. In the realm of metaphysical beliefs, pyrite is thought to bring luck, wealth, and success to its bearers. It is also used to build confidence and promote sexual expression.

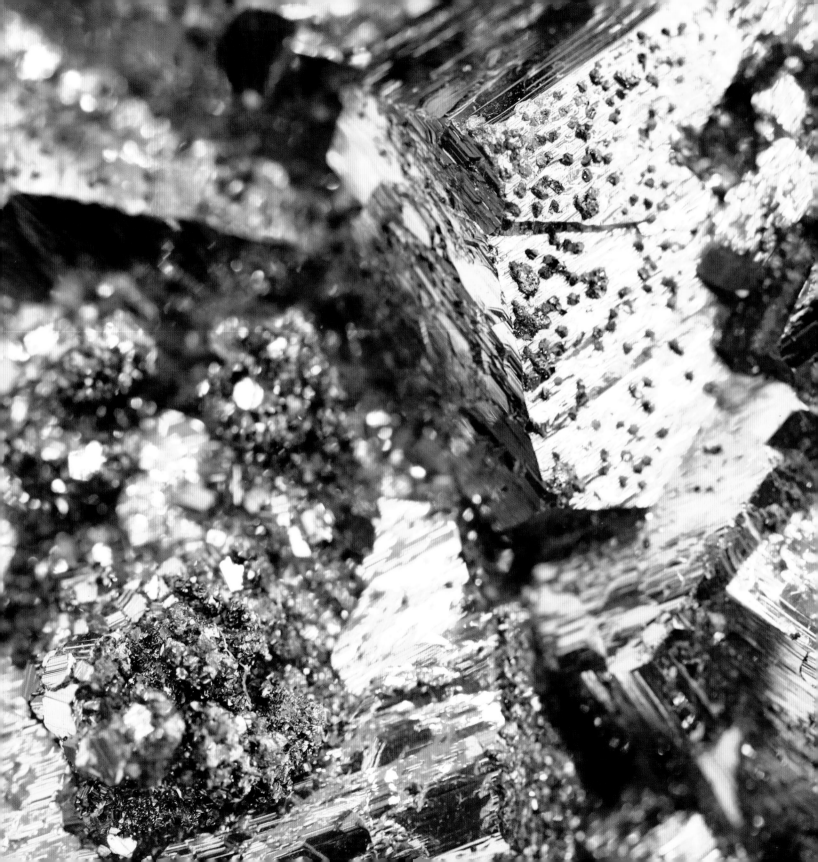

RHODOCHROSITE

KNOWN FOR ITS GORGEOUS PINK COLOR, rhodochrosite's name was derived from the Greek word that describes it, *rhodokhros.* Its most common occurrences are massive formations; single-crystal rhodochrosite is rare and is found mainly in Colorado and South America. Stalactic growths, which look like pink agate, are often called Inca Rose and come from the old Incan silver mines in Catarnarca, Argentina. Small carvings and beaded jewelry are far more common than faceted stones, as the softness of the mineral makes it difficult to work with.

Like most pink stones, rhodochrosite is valued by gem therapists for its ability to attract love. However, it is associated more with self love than with romantic. It has been used to heal deep, unresolved issues that prevent patients from honoring themselves and is also believed to heal nervous system imbalances.

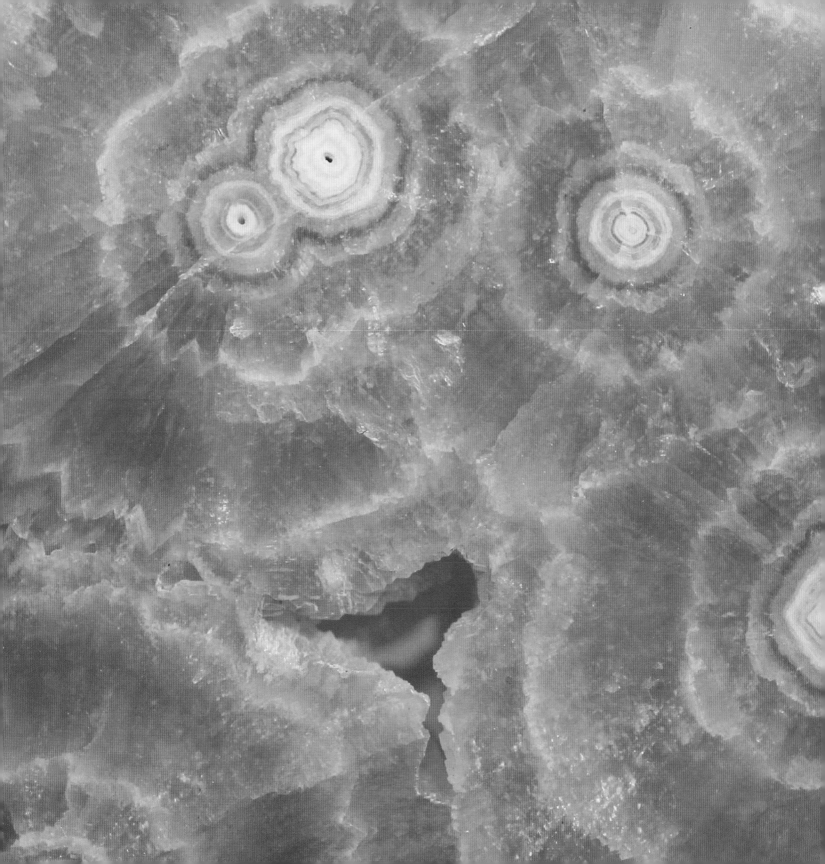

ROSE QUARTZ

ROSE QUARTZ IS THE PALE PINK to deep rose variety of quartz. Prismatic crystals are rare as this quartz usually forms in rock-like masses that can occasionally weigh hundreds of pounds. The pink color is caused by microscopic inclusions of the mineral dumortierite. Significant quarries are located in Madagascar, Brazil, and South Dakota, where some roadside "rock sheds" sell pieces weighing several pounds for a few dollars. Most often cut *en cabochon* in the jewelry trade, fine examples of rose quartz can also be faceted into beautiful gems in the right gem-cutter's hands.

Like most quartz crystals, rose quartz plays an important part in gem therapy and has been used as a love charm for hundreds of years. It is thought to draw love to its wearer and can be especially potent if it is cut in the shape of a heart. It is also believed to open one's heart to all types of love, and it is thought that meditating while holding the stone can open tidal waves of love and acceptance on all physical, emotional, and spiritual levels.

RUBY

RUBY IS THE RED VARIETY of the mineral corundum. In general, only red corundum is considered ruby; when the gem becomes light enough to appear pink, it is called pink sapphire. However, where ruby ends and pink sapphire begins is often a matter of disagreement. To some, there is no pink sapphire, and all red corundum is ruby; others see a distinction between the rich red of ruby and the subtle, velvety shades of pink sapphire. Whatever the name, the color comes from trace elements of chromium. The presence of chromium also disrupts the crystal structure of corundum, and for this reason, fine rubies over 5 karats are exceedingly rare. The finest rubies have historically come from Burma, and early miners in this area believed that the paler colored stones had not yet fully matured into rubies. (A similar belief was held about pale green beryl and emeralds.) Other notable deposits occur in Sri Lanka, East Africa, Afghanistan, and Madagascar. Because of the rarity of fine ruby and the great demand, many poor-quality stones are treated in a variety of ways to achieve a salable appearance.

Rubies have enjoyed continued popularity through the ages, but no one revered them as much as the Burmese, who at the height of their glory owned and operated not only the largest ruby mines in history, but collections of cut stones that would have made the richest pharaoh quake with jealousy. The Burmese believed that a ruby made one invincible, and their warriors were known to insert the jewels under the surface of their skin before battles. The finest rubies in the world, such as the De Long Ruby, a 100.3-karat star ruby, and the Mandalay Ruby, a 48-karat faceted stone, are of Burmese origin. Rubies have been thought to ignite passion in lovers. In ancient Egypt, it was believed that if a woman wore a ruby against her skin, her life would be full of love and happiness. Throughout the Middle Ages, rubies were used medicinally to treat eye, liver, and blood diseases. Rubies, or lack thereof, have also been a major source of disappointment: two highly prized pieces of the English Crown Jewels (the collection of precious ceremonial objects used throughout history and belonging to the English monarchy) were, in fact, spinel. Ruby is the modern and ayurvedic birthstone for July and also the ayurvedic birthstone for December; it is associated with the fifteenth and fortieth wedding anniversaries and is linked to Capricorn and Taurus.

SAPPHIRE

CORUNDUM FORMS IN A RAINBOW OF HUES, but its deep red variety, ruby, and its spectacular blue variety, sapphire, are the most prized. Aside from rubies, all other varieties of corundum are considered to be sapphires, but the soft blue coloration often called Kashmir blue is the most valuable to the gem trade and the most recognizable to the public. Sapphires that contain fine rutile inclusions are cut *en cabochon* to create a star effect across the surface of the stone.

For centuries, sapphires were little known outside of the great deposits in Burma, Sri Lanka, and Thailand. But as trade routes opened, the gems were brought to the attention of kings and queens alike. They have been used for thousands of years medicinally and were linked to eye treatments, curing deadly insect bites, and treating fevers. Greek mythology holds that the first ring ever worn was made of sapphire. It was believed to belong to Prometheus who, as part of his punishment for discovering fire, was made to wear the jewel as a reminder of the hottest parts of the flames he was not ever to coax to life again. Sapphires became especially important to Jews and Christians as a reflection of the heavens, which scholars assume is based on the velvety blue color of many of the stones. Often, to increase the protective powers of the stone, it was engraved with images or text. And some argue that the Ten Commandments were etched into sapphire tablets; though modern research now suggests that the stones referred to were actually lapis lazuli. The sapphire became the stone of choice for the Roman Catholic church, as it was believed to promote chastity and prevented those wearing it from being led morally astray. Scholars believe this may have been the reason that all the bishops wore sapphire rings during the reign of Pope Innocent II. Sapphires are the original birthstone for April and are believed to be the fourth stone in Aaron's Breastplate. They are also the birthstone for August according to ayurvedic charts and are the modern birthstone for September. They are traditionally given as gifts on fifth and forty-fifth wedding anniversaries and are linked to Taurus and Gemini.

SCHORL

COMMONLY REFERRED TO AS BLACK TOURMALINE, the mineral schorl is a species of alkali tourmaline. It is the most abundant type of tourmaline on Earth. It is also known as iron tourmaline because of its iron-rich content. Specimens can be quite large with prismatic crystals stretching out over several yards. Sometimes found as crystal inclusions in clear quartz, called tourmalinated quartz, black tourmaline is used occasionally in modern jewelry and was once a popular mineral to set into Victorian mourning jewelry.

In gem therapy, black tourmaline is thought to be a protective gem, keeping negative energies at bay. Physically it is believed to flush the body of toxins and stress. It is thought that the somewhat rare double-terminated varieties enhance the flow of energies.

SILVER

SILVER IS A NATIVE ELEMENT that has been mined since 4,000 BCE. It is the most malleable metal after gold and for some time was in higher demand than its yellow-hued cousin. The earliest silver mines known are located in Turkey and are still in use today. While Mexico provides a great deal of the silver in the current market, other important deposits are located throughout North America, Australia, and Russia.

Silver has been used in jewelry since it was originally mined. Cultures throughout history have crafted decorations, jewelry, and coins from the metal. Some of the most notable examples of craftsmanship come from the Mesoamerican cultures of Mexico and South America. Silver has played a role in the mythology of many cultures. In Ireland, for example, there is a story about a great king who lost his arm in battle who was given a new arm made of silver by the god of healing so that he could retain his kingdom. In some traditions, it is believed that wearing silver while sleeping will aid in foretelling dreams.

Since ancient peoples began assigning healing and divine properties to metals and minerals, silver has always been associated with female energies, the moon, and the goddess. It is believed to connect one to the female side of the divine and has been used to treat hormonal imbalances. It is also believed to be a highly protective metal, and in Chinese folklore, mothers often place silver lockets around their children's necks to protect them from harm. Silver is used extensively in jewelry design, as it has been for thousands of years, and is the traditional gift to celebrate twenty-fifth wedding anniversaries.

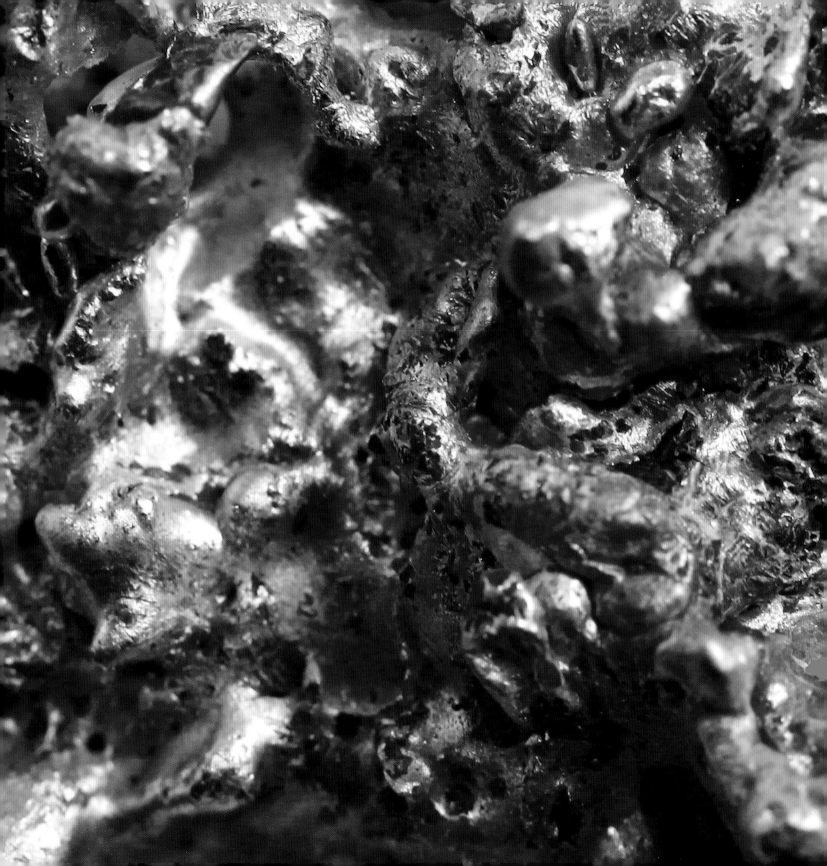

STIBNITE

STIBNITE IS IN THE FAMILY OF SULFIDES and usually forms in long, dark, metallic crystals. It is relatively fragile, with a Mohs hardness of 2, but interestingly, it is used extensively to harden lead. Because of its fascinating crystal structure, it is also popular with mineral collectors. The largest deposits of stibnite are found in the Hunan province of China, with other notable locations in Japan, Bolivia, and Romania.

Stibnite is used in gem therapy to encourage spiritual rebirth. It is associated with Hades, the god of the underworld, and its dark, spiny structure is reminiscent of what one may associate with that realm. It can be used in grounding exercises and with those who hope to attain new perspectives on their own existence. It is also believed to help fight both internal and external physical infections.

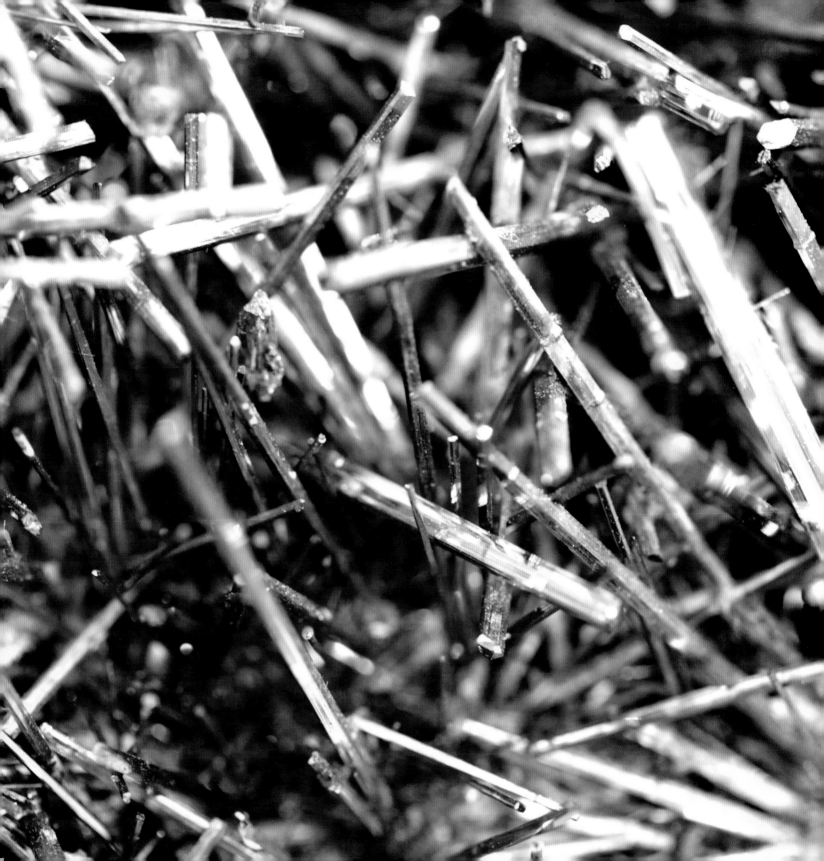

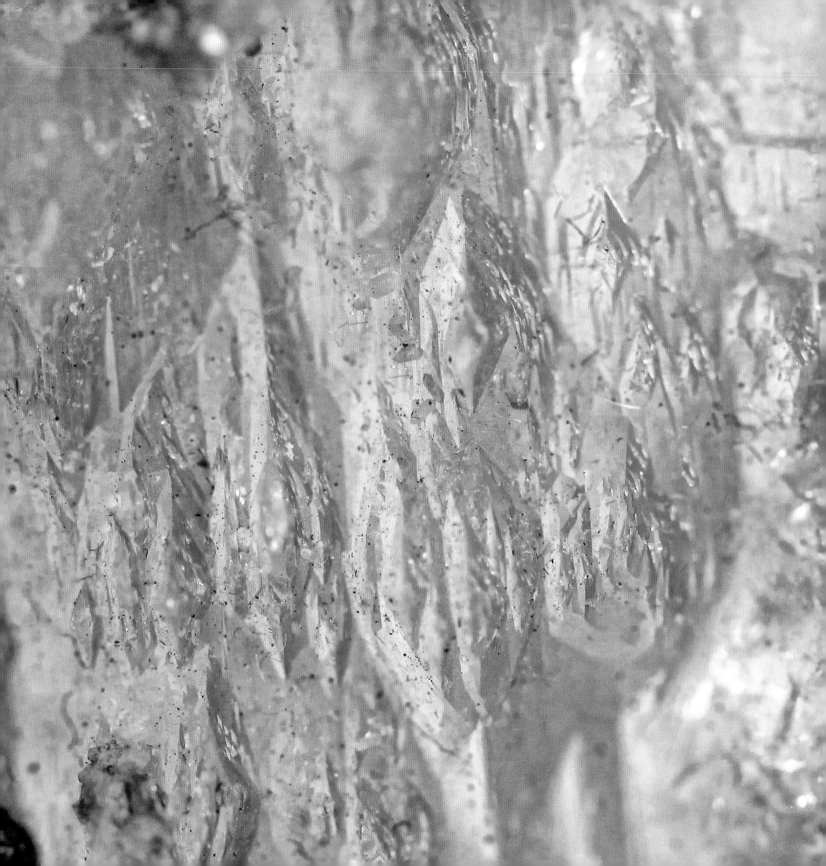

TOPAZ

TOPAZ IS A MEMBER OF THE SILICATES GROUP with well-formed crystals and is found in a variety of colors, sometimes in colossal formations that are measured in pounds. There are two predominant beliefs about the derivation of the name topaz: one is that it comes from the Sanskrit word *tapaz* meaning "fire"; the other is that it is named for the ancient island of Topazios (now known as St. John's Island) in the Red Sea, where the stone was thought to have been found originally. However, this second origin is in dispute because we now think that the island was actually rich in olivine (see peridot) deposits, not topaz. It must be noted, however, that the gem was often misidentified in its early applications; a seventeenth-century crown once thought to hold one of the largest diamonds ever mined is now believed to have held a colorless topaz.

While topaz is found in a variety of colors, the most popular in both the gem trade and gem healing are blue topaz, yellow (or golden) topaz, and pink topaz. Pink is rare, and most examples you see set into jewelry today are heat-treated yellow Brazilian topaz. Likewise, colorless topaz, the most abundant variety, is often irradiated to create the most desirable blues. Used as a talisman throughout the ages, common uses for the stone were to ward off the evil eye, to cure eye troubles, to fight depression and insomnia, to revitalize taste, and even to cure the plague (by a Roman physician in the fifteenth century). Topaz is the modern and ayurvedic birthstone for November and is associated with the zodiac sign Sagittarius.

TOURMALINE

TOURMALINE IS THE NAME OF A GROUP of minerals that have a similar crystal structure; however, the fourteen known species vary greatly in chemical composition. They encompass some of the most colorful minerals found on Earth. Throughout ancient history, tourmalines were often mistaken for gems of much higher repute. The tourmaline elbaite—named for the island of Elba, Italy—makes up the majority of gemstone-quality minerals within the group, and even it varies greatly in color. Three of the most popular color variations are verdelite (green, pictured opposite), rubellite (red or pink, shown above), and indicolite (blue). These varieties do not necessarily correspond to specific tourmalines; most species occur in a variety of colors, and specimens showing more than one color are common. The name *tourmaline* comes from the Sri Lankan word for "gem pebbles," as its crystals are resilient against heavy weathering and were often found in gravel deposits. Once mined heavily in Southern California and the Mount Mica Mines in Maine, its largest deposits are now found in Africa and Brazil.

Verdelite (green) is prized in the gem trade for its rich hues and abundance. Until the eighteenth century, it was not uncommon for the brighter specimens to be misidentified as emeralds. Because of this confusion, there is little reference to tourmaline in European gem lore. Gem therapists believe that green tourmaline aids in connecting one to the physical world and that it creates a feeling of wholeness in its bearer. Rubellite (red/pink) was also historically confused for the more valuable ruby. It is believed that Catherine the Great of Russia possessed a large crown jewel she thought was a ruby that was later discovered to be a rubellite. However, rubellite has remained a popular alternative to ruby, and the last empress of China, Tzu Hsi, forever lays her head on a "pillow" carved of rubellite in her tomb. Neon-blue indicolite, also called Paraíba in the gem trade after the Brazilian state where it was first found, is the most highly prized (and expensive) tourmaline variety. Metaphysical practitioners recognize the stone as a powerful talisman to reconnect people to their true passions for life. Pink tourmaline is also associated with the month of October.

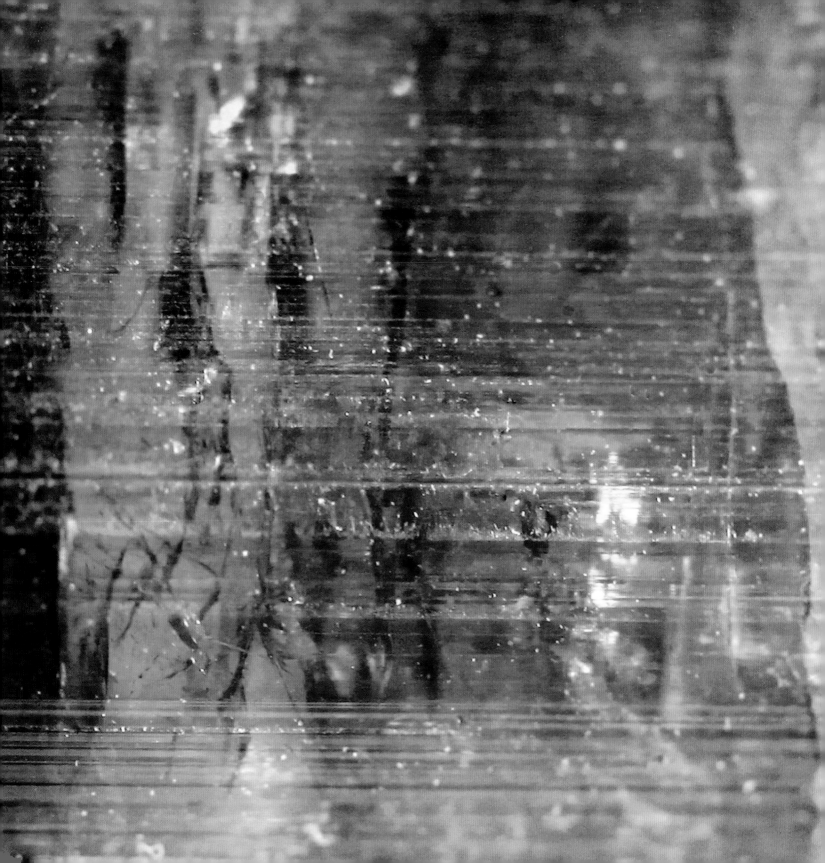

TURQUOISE

ONE OF THE MINERALS LONGEST REVERED for its beauty and power is turquoise. It is also one of the first gemstones to be mined. Named for the trade route through Turkey, the stone originally came to Europe from ancient Persia. Elements such as iron and copper determine the color and hardness of the turquoise, the presence of iron yielding a greener stone and of copper a bluer. Primarily mined in arid environments, turquoise is most commonly found in the American Southwest, the Middle East, South America, Eastern Asia, and Australia.

The legends and mythology that surround turquoise are as varied as the locations in which it is mined. It is one of the few gemstones to be worn by kings and common citizens alike. Prevalent in many Native American legends, it is considered to be a holy stone. The Pueblo Indians believed that turquoise derived its colors from the blue skies and thus called it Sky Stone. It still plays a vital role in the lives of traditional Navajo, who rely on the stone's healing and protective charms. The Apache believed that a medicine man was powerless without the stone, and Aztecs placed a turquoise bead in the mouth of their dead as a gift to the spirits upon the body's arrival in heaven. Ancient Egyptians believed it to be a powerful healing stone as well, and it is one of the gemstones most used in their ornamentations and carvings; Tibetan culture prizes turquoise for both ritual and medicinal purposes. Western cultures have also cherished the stone, which was once considered a love talisman in England, Germany, and Russia.

Today, turquoise is most likely to be found in jewelry. It is the birthstone for December and is linked to the sign of Sagittarius. Because the stone is opaque and does not refract light, it is rarely faceted, but is instead cut *en cabochon* and polished. Some of the finest finished pieces are created by Native American, Iranian, and Tibetan craftspeople who still honor the power of this ancient gift from the earth.

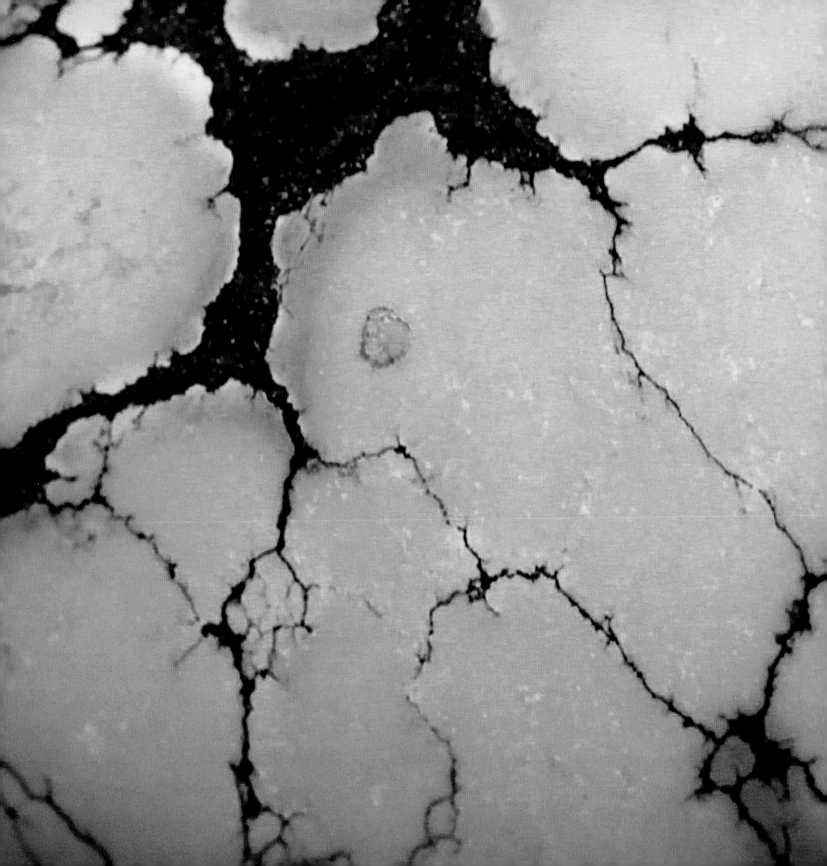

MORE MINERALS

There are hundreds of species of minerals, and many of those have several varieties. We did not have room to cover every rock, mineral, and gem in this little book—but the following are also worthy of a mention based on their historical significance in the gem trade, appeal to collectors, and popularity in the New Age realm of gem therapy.

ALEXANDRITE: Alexandrite is a variety of chrysoberyl. Named for Tsar Alexander II of Russia, the stone is renowned for its ability to change colors under different lighting conditions. The mines in Russia are depleted, but current deposits are found in Brazil and Sri Lanka. It has been used in jewelry since its discovery in 1830 and metaphysical practitioners believe it to be a powerful tool for spiritual growth and inner wisdom. It is thought to bring great joy to those who use it. All types of chrysoberyl are linked to the sign Virgo.

AVENTURINE: A type of quartz, aventurine is often green (and is occasionally confused with amazonite) but can also be reddish-brown due to traces of hematite and brown due to pyrite. It is mined heavily in the Ural Mountains of Russia and is used primarily for jewelry. Gem therapists use the stone to encourage confidence and to improve one's overall outlook on life.

HEMIMORPHITE: An unusually beautiful growth pattern makes hemimorphite easily recognizable among collectors—small crystals form in bubble-like patterns on the surface of host rocks. It is mined in Africa, Germany, Italy, and Greece. While it is found in shades ranging from pale yellow to blue, the turquoise-blue variety is popular in gem healing and is thought to instill feelings of overall well-being.

JADE: Throughout history, many materials have been referred to as jade, but modern authorities define it as one of two materials, jadeite or nephrite. Both occur in a variety of colors and have long histories of both ornamental and utilitarian uses. Jadeite was used heavily in early Mesoamerican cultures, while nephrite has been mined in China for thousands of years, where it was once believed to be the petrified tears of a dragon. Fine Imperial Green jadeite, which can rival the finest emeralds in color, is the most highly prized for jewelry use, but ornate nephrite carvings created by Chinese craftspeople are also highly valued. Jade is linked to the sign Libra.

JET: Jet is an organic gem and a form of lignite coal. Gem historians believe that along with amber, jet may have been one of the earliest stones used ornamentally by

prehistoric humans. Though quite soft and brittle for a gem material, it has been prized for its deep black color. Its popularity soared in England when Queen Victoria, mourning the loss of her husband, began to wear the stone to accompany dark clothing. The deposits in Whitby, England, became a popular source of jet during this time and remain so to this day.

KUNZITE: The pink or pale purple variety of spodumene, kunzite was named after famed mineralogist George Frederick Kunz. Major sources are in Brazil, Afghanistan, and Pakistan. Because of its perfect cleavages and poor durability, the stone is not well-suited for jewelry use despite its attractive colors. However, it remains a popular addition to collectors' cabinets because of its well-formed crystals. Metaphysical practitioners believe the stone is a gateway to unconditional love and the realization of great joy in the everyday.

MARCASITE: Chemically identical to pyrite but forming in a different crystal system, marcasite is mined worldwide including in the United States, Germany, Japan, and Bolivia. In early mining history, marcasite was often mistaken for gold by the inexperienced, and it was used heavily in Art Deco jewelry settings in the United States. New Age practitioners believe that it is

a powerful mineral to facilitate connections between one's physical and spiritual existence.

MOLDAVITE: Moldavite is a type of tektite, a natural glass like obsidian, but one formed by meteorite impact. Tektites were created when large meteors impacted the earth's surface with sufficient force to throw molten rock into the atmosphere. Bits of melted silica then fell back to Earth, cooling rapidly to glass. Moldavite is the tektite found in the Bohemia region of the Czech Republic. It has been found in burial sites of Neolithic humans and at the feet of the Venus of Willendorf (the earliest known representation of goddess worship), and has been connected to the mythology of the Holy Grail. The fact that moldavite essentially fell from the sky has made it a favorite healing stone among New Age communities, and it is thought to symbolize the new age of awakening.

MORGANITE: A type of beryl (like aquamarine and emerald), morganite is the pinkish-orange variety of the mineral. Named for collector and banker J. Pierpont Morgan, it is primarily mined in Brazil, Italy, California, and Africa. In gem therapy, it is used to connect users with divine and spiritual love and is thought to imbue its wearer with inner and physical strength.

OBSIDIAN: Formed when lava with high silica content cools so rapidly that crystals do not have time to form, obsidian is a glass as opposed to a mineral. It has been used to create tools and weapons for thousands of years, and the Greeks also used its reflective properties as mirrors. Small nodules of obsidian are sometimes found in Mexico and the American Southwest, where they are called Apache Tears. The name comes from an Apache story that a group of warriors were forced by pursuing cavalry to ride over a cliff to meet their death. The tears of the Apache women solidified and are scattered across the landscape as a reminder of the tragedy.

ONYX: A striped variety of chalcedony, onyx is best known for its parallel black and white bands. The stone has had a tumultuous history in gem lore. It was believed to create discord between lovers and was even believed to cause divorce if worn by the couple. Metaphysical beliefs, however, restore confidence in the stone. It is now believed to enhance inner strength and endurance and is used in grounding exercises. Onyx is the alternative birthstone for July and is associated with the sign Leo.

SELENITE: The colorless to translucent-white crystal variety of gypsum, selenite can grow into enormous, meters-long crystals when the conditions are ideal. Two of the most notable deposits that feature such growths are in New Mexico and in the Cave of Swords in Mexico. Because of the way selenite is formed, it is often used as a wand in New Age healing. For example, it is thought that laying a wand of selenite down a patient's spine encourages spiritual alignment.

SODALITE: Named for its sodium content, sodalite is an intense blue mineral that has been occasionally misidentified as lapis lazuli, especially as the two often occur together. It is usually cut *en cabochon* for jewelry and tumbled for amateur collectors. It is found throughout the world, with notable deposits in Brazil and India. Used for meditation and trance work in gem therapy, it is also believed to regulate blood pressure.

SPINEL: Spinel is both a group of minerals and a variety of a mineral within that group. Though it is found in a rich variety of colors, the most widely known is a beautiful blood-red color that has placed the gem on the road to immortality. Red and pink spinel was mistaken for ruby so regularly that two historic examples are part of the collection of English Crown Jewels. Both the

Timur Ruby, whose last owner was Elizabeth II, and the Black Prince's Ruby set into the English Imperial State Crown, were later discovered to be fine spinels.

SUGILITE: Considered to be one of the most powerful minerals in gem therapy, sugilite was discovered in 1944. Though it can vary in color, most examples set into jewelry and used in metaphysical practices are purple. It is believed to have many benefits including illuminating spiritual pathways, protection from the negative energy of others, and attracting love, and it is used as a powerful tool in dream prophecy.

TANZANITE: The gem-quality, bluish-purple variety of the mineral zoisite, tanzanite was only recently discovered near Mount Kilimanjaro, in 1967. It is thought to be a thousand times rarer than diamonds. The only known deposits are located in Tanzania and Kenya. Due to its scarcity, high-quality tanzanite is relatively expensive and is usually used in fine jewelry settings. Most tanzanite is naturally brown and must be heated to bring out the blue color. In metaphysical practices, the stone is thought to link the heart and mind and make its wearer more compassionate.

TIGER'S EYE: A member of the quartz family known for its striking gold and brown bandings, tiger's eye (also referred to as tiger-eye) is formed by a process called pseudomorphous replacement, in which quartz replaces another mineral—in this case, asbestos—assuming its form. The unique appearance of tiger's eye is caused by reflectance from the parallel fibers of quartz, an effect also known as chatoyancy. It is often cut into round beads and spheres to enhance this effect. In gem therapy, it is used to encourage mental clarity and is believed to have a strong ability to ease tension between those going through relationship difficulties such as divorce.

ZIRCON: The only natural colorless gem whose fire and brilliance is on par with diamonds, zircon has often been confused with man-made cubic zirconia. However, zircon is a naturally occurring mineral that has been mined for more than 2,000 years. It is also the oldest reliably dated mineral on Earth—a zircon crystal from Australia was dated to 4.4 billion years old. Zircon that occurs in yellow and orange to red hues was called jacinth (or hyacinth) and is the original birthstone for January and one of the stones said to be in Aaron's Breastplate.

ZODIAC AND BIRTHSTONE CHARTS

hy does someone born in December wear a turquoise? What is the connection between someone born under the sign of Aries and a bloodstone? Is it a modern marketing tool of the gem trade to sell more jewels, or is it something much deeper? While links to stones and signs of the zodiac date back to ancient Greece, associations between the months of the year and stones date back to the book of Exodus in the Bible. In the story, God gave specific instructions to Moses to create a *Hoshen* (breastplate) for his brother Aaron, the High Priest of the Israelites. The twelve stones that God commanded Moses to place into the *Hoshen* are mentioned by name, though new interpretations of Exodus and modern identification of minerals has altered the list slightly through the ages. One debate surrounds the inclusion of a diamond. Since the stones were meant to represent the original twelve tribes of Israel, many scholars agree that God would not have singled out one tribe greater than the other by using a diamond to represent it. Many years later, Flavius Josephus, a Jewish historian, confirmed in his own writings that early Judaic practices aligned the stones not only with the tribes, but also with the months of the year and even the Greek zodiac. In this vein, Christian writers began creating lapidaries connecting stones to their own religious world in the first century.

But it was an avid collector and mineralogist who may have unveiled the truth behind the modern fascination with birthstones. American-born George Frederick Kunz is considered the authority when it comes to gem lore. Although his books were published in the early 1900s, they remain important documents regarding the historical and mythological significance of gemstones. In his book, *The Curious Lore of Precious Stones*, Kunz makes the connection between Jews settling in Poland during the eighteenth century who honored the story of the *Hoshen* and the modern interest in stones. These Polish Jews eventually emigrated to North America in the early 1900s and brought with them their religion, culture, and perhaps, the idea of birthstones.

Since the first "official" birthstone chart was established by the National Association of Jewelers in 1912, it has gone through several changes. What you see on the charts included in this book is just a small sampling of the months linked to certain stones. Throughout history, different cultures have had their own interpretations of both birthstones and zodiac stones. Here we share with you the most recognized. The stones associated with zodiac signs are based on both the original Greek charts and on research by renowned zodiacal practitioner Rupert Gleadow in his book *The Origin of the Zodiac.*

BIRTHSTONES

MONTH	BIBLICAL	AYURVEDIC	MODERN {PRIMARY}	MODERN {SECONDARY}
January	Jacinth	Garnet	Garnet	Jacinth
February	Amethyst	Amethyst	Amethyst	Pearl
March	Jasper	Bloodstone	Aquamarine	Bloodstone
April	Sapphire	Diamond	Diamond	Clear Quartz
May	Chalcedony	Agate	Emerald	Agate
June	Emerald	Pearl	Pearl	Moonstone
July	Sardonyx	Ruby	Ruby	Onyx
August	Sardius	Sapphire	Peridot	Carnelian
September	Chrysolite	Moonstone	Sapphire	Lapis Lazuli
October	Beryl	Opal	Opal	Pink Tourmaline
November	Topaz	Topaz	Topaz	Citrine
December	Chrysoprasus	Ruby	Turquoise	Zircon

GEMS OF THE ZODIAC

ZODIAC SIGN	GEMS AND STONES
Aries	Bloodstone, Crystal Quartz, Hematite
Taurus	Sapphire, Malachite, Ruby
Gemini	Agate, Citrine, Sapphire
Cancer	Emerald, Calcite, Agate
Leo	Onyx, Amber, Carnelian
Virgo	Carnelian, Amethyst, Chrysoberyl
Libra	Chrysolite, Chrysoprase, Jade
Scorpio	Aquamarine, Garnet, Hematite
Sagittarius	Topaz, Lapis Luzuli, Turquoise
Capricorn	Ruby, Fluorite, Chalcedony
Aquarius	Garnet, Hematite, Amethyst
Pisces	Amethyst, Fluorite, Opal

METAPHYSICAL NOTES

The philosophical study of our reality—what is tangible and, in some ways more important, what is not—is metaphysics. The term is used rather broadly, and different groups of people have slightly different understandings of it. In this book, the word is used to describe a group that believes in the ideology of transcendence—the belief that certain things have a reality outside our own. Whether or not you believe that certain minerals radiate power and energy, the folklore of these gems has been documented for thousands of years. You do not have to be pagan or Wiccan to believe the lore; you do not have to practice metaphysics to practice your own version of gem therapy; and you do not have to believe or practice anything—you can simply love to look at and admire these specimens for their physical beauty alone.

For those interested in gem therapy, you will find a few notes below on how to best care for and use your gems and minerals as well as a bit of lore that has been used for thousands of years to connect minerals with their bearers.

(*Please note:* The notes are intended to be used with gems and minerals used in jewelry, carried in pouches, and used in healing exercises, not cabinet specimens. Please research your individual mineral type for the best cleaning solution before subjecting your stones to anything other than water.)

CLEANSING: Many practitioners think that when you acquire a new gem you should cleanse the stone of spiritual impurities before employing it for personal use. Gem therapists tend to believe that salt water is the ultimate purifier. You can use natural sea water or make your own. Simply fill a clean 8-ounce glass or ceramic cup (do not use plastic or metal) with tepid water, add roughly a tablespoon of sea salt, and stir until the salt dissolves. Then place your mineral in the glass for up to twenty-four hours. Some softer minerals cannot take this treatment, however, and are best cleansed in a pure, tepid water bath. Dry your stone in either the light of the sun for an hour or the light of the full moon overnight. You might use an additional cleansing practice involving herbs. To do this, bury your stone in a mixture of sage and frankincense overnight or pass the stone through the smoke of sage incense. Many practitioners bury their stones in the earth for up to a week to be spiritually cleansed—just be sure to mark where you've buried them!

CHARGING: Once your stone is clean, it is ready to be charged. Charging simply means placing your purest intention—what you are asking of the stone—into the mineral itself. Those gems already identified with specific properties (for example, citrine is thought to aid in achieving creative potential) are the best ones to

use when asking for specifics. (In the case of citrine, your intention may be the vision and inspiration to finish a work of art.) There are two primary methods used to charge stones. The first is sunlight. Placing the stone in direct sunlight allows the sun to fill the stone with its natural energies and refuel its metaphysical properties, thereby making it a stronger tool in gem therapy. Certain stones should not be exposed to direct sunlight for more than an hour or so at a time because the sun can cause their natural colors to fade. The second practice has to do with moonlight—and it is important that you take into account the phase of the moon. Each phase of the moon can be used to harness specific requests. The energy associated with the full moon is abundant, strong, and full of intention. When the moon is waxing (growing toward a full moon), it is a good time to ask the universe for something you may need more of—love, work, healing. When the moon is waning (growing smaller), practitioners use this time to try and rid things from their lives—sickness, unstable relationships, etc. Finally, when the moon is new (appearing like a dark shadow in the sky), it is believed to be an excellent time to work toward rebirth, growth, and change. Place your stone under the moon overnight to absorb these energies. This type of "moon magic" has been used for thousands of years.

After your stones are ready for your personal use, you can coax your minerals to work with you in any of the ways described below. Many of these methods have been used by ancient civilizations including Meso-american and Native American, Early Mesopotamian, Egyptian, and Celtic cultures and continued to be used and expanded on in the Middle Ages and Renaissance. For further reading on gem healing and lore, please see the Resources section for a list of books on the subject.

◇ Medicine men throughout tribal history have been considered powerless without their "pouches." It has become a common practice for a person who believes in the metaphysical properties of stones to carry a small pouch of minerals. When selecting the stones you would like to carry, it is important to note not only what you wish to manifest from the gems, but the combinations as well. It is important that you not carry stones whose energies cancel each other out. Additionally, it is thought that a natural fabric pouch—especially one that is made by the wearer—purifies and deepens intentions.

◇ It is believed that allowing the stone itself to touch the wearer's skin, perhaps by using a gemstone with an opening on the back of the setting, will facilitate the absorption of the energies of the gem. In ancient Egypt, it was believed that when women wore

rubies against their skin, their lives would be full of happiness. However, again you must use caution here as some very porous gems such as turquoise can change color with prolonged skin contact.

◇ Sleeping with stones is a frequent practice. Absorbing the stone's energy when one is in the most relaxed state is powerful. It is thought that putting certain minerals under one's pillow will grant foretelling dreams. Mothers in Medieval Europe often placed malachite under the pillows of their sleeping children to prevent nightmares.

◇ Another practice for absorbing crystal energies is the mineral bath. Placing the mineral around your bath or, more effectively, in the water itself, allows the properties of the mineral to be absorbed into the practitioner. Use caution when selecting stones for this use, as some minerals are toxic when absorbed into the body.

◇ Gem essences have been used for thousands of years. One, called a moon elixir, is created by placing a stone in a glass of water under a full moon overnight. It is thought that drinking the charged contents (save the stone, of course!) will manifest the energies of that gem. Some believe that elixirs can be used for up to a month by simply adding a few drops to a daily glass of water; some find more success by sipping straight from the elixir glass throughout the following day. Users also add droplets to bathwater and combine drops with homemade, natural home cleansers. Gem essence can also be made by exposing the water and stone to sunlight rather than moonlight. Again, be aware of which minerals have toxic properties.

RESOURCES

Here you will find a list of noteworthy international collections; wonderful rock, mineral, and crystal shops; and jewelers using minerals in the most beautiful and unusual ways as well as artists and designers who are inspired by minerals.
Find out more at www.gemandstonebook.com

MUSEUMS WITH NOTABLE MINERAL COLLECTIONS

American Museum of Natural History:
www.amnh.org

Australian Museum:
www.australianmuseum.net.au

California Academy of Science:
www.calacademy.org

Canadian Museum of Nature:
www.nature.ca/en

Carnegie Museum of Natural History:
www.carnegiemnh.org

Ben E. Clement Mineral Museum:
www.clementmineralmuseum.org

Cleveland Museum of Natural History:
www.cmnh.org

Colburn Earth Science Museum:
www.colburnmuseum.org

Colorado School of Mines Geology Museum:
www.mines.edu/Geology_Museum

Denver Museum of Nature and Science:
www.dmns.org

Field Museum: www.fieldmuseum.org

Franklin Mineral Museum:
www.franklinmineralmuseum.com

Houston Museum of Natural Science:
www.hmns.org

Mineralogical Museum at Harvard University:
www.fas.harvard.edu/~geomus/

Mineral Museum of Michigan/ A. E. Seaman Mineral Museum:
www.museum.mtu.edu

Museum Victoria:
www.museumvictoria.com.au

Natural History Museum, London:
www.nhm.ac.uk

Oxford University Museum of Natural History: www.oum.ox.ac.uk

San Diego Natural History Museum:
www.sdnhm.org/

Smithsonian National Museum of Natural History:
www.mineralsciences.si.edu

Tellus Science Museum:
www.tellusmuseum.org/

Utah Museum of Natural History:
www.umnh.utah.edu

Yale Peabody Museum of Natural History: www.peabody.yale.edu

MINERAL AND ROCK SHOPS

Some of the best shops to start your own mineral collection:

The Agate Trader:
www.theagatetrader.com

Arizona Mineral Company:
www.arizonaminerals.com

The Big Rock Shop:
www.bigrockshop.com

Broadstone Minerals:
www.broadstoneminerals.com

CK Minerals:
www.ckminerals.com.au

Colorado Gem & Mineral Co.:
www.coloradogem.com

Cornwall and Devon Minerals:
www.cornwalldevonmineral
specimens.co.uk

Crystal Classics:
www.crystalclassics.co.uk

Crystals of the World:
www.crystalsoftheworld.com

Crystal Vine: www.crystalvine.co.uk

Crystal Works: www.crystalworks.ca

Dragon Minerals:
www.dragon-minerals.com

Earthquest Minerals:
www.earthquestminerals.com

Edwards Minerals:
www.edwardsminerals.com

Enter the Earth:
www.entertheearth.com

E-Rocks Mineral Auctions:
www.e-rocks.com

Exquisite Crystals:
www.exquisitecrystals.com

Fabre Minerals:
www.fabreminerals.com

Gem Quarry: www.gemquarry.com

Geode Gallery:
www.geodegallery.com

Green Mountain Minerals:
www.greenmountainminerals.com

John Betts Fine Minerals:
www.johnbetts-fineminerals.com

Junior Geo: www.juniorgeo.co.uk

Kristalle: www.kristalle.com

Little Gems:
www.littlegemsrockshop.co.uk

Miner's Lunchbox:
www.minerslunchbox.com

Mirrorstone Crystals:
www.mirrorstonecrystals.com

Montgomery Crystal Company:
www.montgomerycrystalco.com

Mount Minerals:
www.mountminerals.com

North Star Minerals:
www.northstarminerals.com

Oak Rocks: www.oakrocks.net

On the Rocks Altea:
www.ontherocks.eu

Paul Lowe Minerals:
www.lowestone.com

Points of Light: www.pointsoflight.net

Riviera Fine Minerals:
www.riviera-1minerals.net

Siber+Siber: www.siber-siber.ch

Simon Hildred Fine Minerals:
www.simonhildredfineminerals.com

Spectrum Minerals:
www.spectrumminerals.com

Stone Art Traders:
www.stonearttraders.com

Thompson Minerals:
www.thomsonminerals.com

Toprock: www.toprocks.com

Top Shelf Minerals:
www.topshelfminerals.com

Weinrich Minerals:
www.danweinrich.com

Wilensky Fine Minerals:
www.wilenskyminerals.com

Wright's Rock Shop:
www.wrightsrockshop.com

JEWELERS, ARTISTS, DESIGNERS, AND SHOPS

Adina Mills Designhouse:
www.adinamills.com
Large, raw, cut minerals paired with unique natural settings.

Ann Sacks: **www.annsacks.com**
Jewelry-grade stone tiles for bath and kitchen, including onyx and turquoise.

Becky Kelso: **www.beckykelso.com**
Intricate metalwork coupled with unusual and beautiful cut gems.

Beth Orduna: **www.ordunadesign.com**
Amazing settings and stone combinations.

Billy Bride: **www.billybride.com**
Large rough and uncut minerals set in sterling rings.

Brook & Lyn: **www.brookandlyn.com**
Known for their large sliced agate necklaces set in hand-crocheted borders and roped finishes.

Carly Waito: **www.carlywaito.com**
Waito creates gorgeous lifelike paintings of assorted minerals.

Cori Kindred: **www.etsy.com/shop/corikindred**
Inspired by old-fashioned specimen boxes, Kindred creates hers with a unique twist.

Cosa Fina: **www.cosafinajewelry.com**
One of the first designers to combine raw stone with refined settings.

Crystal Cache:
www.thecrystalcache.com
Bookends, bowls, lamps, candle-holders, and more—all crafted from minerals.

Eduardo Garza:
www.eduardogarza.com
Luxury napkin rings, bookends, boxes, and drawer pulls crafted from raw minerals and 24-karat gold.

Emily Armenta:
www.armentacollection.com
Settings that look like long-lost crown jewels and newly discovered buried treasures.

The Fossil Store:
www.thefossilstore.com
Full of unique home accessories including carnelian bowls, mineral spheres, and cabinet and framed specimens.

Gem Decor: **www.gemdecor.com**
Stocks gemstone tabletops, sinks, mirrors, and more.

Goldsmith Silversmith:
www.goldsmithsilversmith.com
Unique and beautiful settings by a team of seven designers.

Heather Kita: **www.etsy.com/shop/feathertreestudio**
Beautiful settings that respect the gemstones' organic forms.

Irene Neuwirth:
www.ireneneuwirth.com
Semiprecious varieties are treated like royalty in this designer's unique collections.

Jamie Joseph: **www.jamiejoseph.com**
Known for their innovative stone cuts and setting diamonds within semi-precious stones.

Kelly Wearstler:
www.kellywearstler.com
The famed interior designer is known for her use of large mineral specimens as interior accents. She has also designed textiles and home accessories inspired by minerals and gemstones.

Kingman Tile: **www.kingmantile.com**
Specializes in natural coral, turquoise, and sandstone tiles for home decor.

Nak Armstrong:
www.nakarmstrong.com
Intricate metalwork and unusual jewels make up his collections.

Nava Zahavi: **www.navazahavi.com**
Her organic-like settings and stone cuts have a worldwide following.

Nga Waiata: **www.ngawaiata.com**
Large semiprecious nuggets set in wooden rings.

Pamela Love: **www.pamelalovenyc.com**
Love's work is crystal heavy and her uses push the boundaries of conventional jewelry design.

Pat Flynn: **www.patflynninc.com**
His goldsmith work pushes boundaries and combines rough finishes with precious stones.

Points of Light: **www.pointsoflight.net**
Store features assorted sizes of gallery-worthy specimens for home decor.

RabLabs: **www.rablabs.com**
Featuring natural mineral platters trimmed in gold, bottle stoppers, and more.

Sophie Monet:
www.sophiemonetjewelry.com
Another talent combining the beauty of natural woods and gemstones.

Stone & Honey:
www.stoneandhoney.com
Known for her sliced agate necklaces overlaid with beautiful sterling and gold patterns.

Uncommon Goods:
www.uncommongoods.com
Selection of agate plates and bowls.

UnEarthen: **www.seeunearthen.com**
One-of-a-kind necklaces that feature crystals and gems set inside spent bullet casings.

Van Dyke's Restorers:
www.vandykerestorers.com
Selection of hardware includes pyrite and quartz doorknobs.

Vanessa Dee: **www.vanessadee.com**
This Paris-based designer mixes waxed leather and faceted stones.

VivaTerra: **www.vivaterra.com**
This online retailer specializes in gifts from the earth including agate plates and coasters and raw crystal votives.

REFERENCES

FURTHER READING AND BOOKS
USED AS REFERENCES FOR
THIS BOOK

Bonewitz, Ronald L. *Rock and Gem.* New York: Dorling Kindersley, 2008.

Burke, John G. *Cosmic Debris: Meteorites in History.* Berkeley: University of California Press, 1991.

Crowe, Judith. *The Jeweler's Directory of Gemstones: A Complete Guide to Appraising and Using Precious Stones from Cut and Color to Shape and Settings.* Richmond Hill, Ontario: Firefly Books, 2006.

Cunningham, Scott. *Cunningham's Encyclopedia of Crystal, Gem & Metal Magic.* St. Paul, Minnesota: Llewellyn Publications, 1988.

Finlay, Victoria. *Jewels: A Secret History.* New York: Random House, 2007.

Gienger, Michael, and Joachim Goebel. *Gem Water: How to Prepare and Use Over 130 Crystal Waters for Therapeutic Treatments.* Forres, Scotland: Findhorn Press, 2008.

Gleadow, Rupert. *The Origin of the Zodiac.* New York: Dover, 2001.

Grande, Lance, and Allison Augustyn. *Gems and Gemstones: Timeless Natural Beauty of the Mineral World.* Chicago: University of Chicago Press, 2009.

Hall, Judy. *The Encyclopedia of Crystals.* Minneapolis, Minnesota: Fair Winds Press, 2007.

Kennedy, Teresa. *Gems of Wisdom, Gems of Power.* New York: Da Capo, 2007.

Knuth, Bruce G. *Gems in Myth, Legend and Lore.* Parachute, Colorado: Jeweler's Press, 2007.

Kunz, George Frederick. *The Curious Lore of Precious Stones.* New York: Dover Publications, 1971.

Kunz, George Frederick. *The Magic of Jewels and Charms.* New York: Dover Publications, 1997.

Lowry, Joe Dan, and Joe P. Lowry. *Turquoise: The World Story of a Fascinating Gemstone.* Layton, Utah: Gibbs Smith, 2010.

O'Donoghue, Michael, ed. *Gems,* 6th ed. London: Robert Hale, 2008.

Pellant, Chris. *Rocks and Minerals.* New York: Dorling Kindersley, 2010.

Simmons, Robert. *Stones of the New Consciousness: Healing, Awakening and Co-creating with Crystals, Minerals and Gems.* Berkeley, California: North Atlantic Books, 2009.

Simmons, Robert, and Naisha Ahsian. *The Book of Stones: Who They Are & What They Teach.* Rev. ed. Berkeley, California: North Atlantic Books, 2007.

Thomas, William, and Kate Pavitt. *The Book of Talismans, Amulets and Zodiacal Gems.* 2nd ed. Seattle, Washington: Createspace, 2009.

Wise, Richard W. *Secrets of the Gem Trade: The Connoisseur's Guide to Precious Gemstones.* Lenox, Massachusetts: Brunswick House Press, 2006.

ONLINE RESOURCES

Gemological Institute of America: **www.gia.edu**

Mineralogy Database: **www.mindat.org**

The Mineralogical Record: **www.minrec.org**

INDEX